THE COMING OF JESUS

The Real Message of the Bible Codes

THE COMING OF JESUS

The Real Message of the Bible Codes

Bonnie Gaunt

Adventures Unlimited Press
Kempton, IL 60946, U.S.A.

Adventures Unlimited Press
P.O. Box 74
Kempton, IL 60946, U.S.A.

For additional information, write to:
Bonnie Gaunt, 510 Golf Avenue, Jackson, Michigan 49203,
U.S.A., (Telephone 517-784-3605)

Manufactured in the United States of America

ISBN 0-932813-70-4

Library of Congress Card No. 99-94049

Acknowledgement: Appreciation is given to Kregel Publica-
tions, Grand Rapids, Michigan, USA, for the use of the illustra-
tions of the constellations. These drawings are from the book
The Gospel in the Stars, by Joseph A. Seiss, first published in 1882
by E. Claxton & Company, Philadelphia, and later published
by Kregel Publications in 1972.

Foreword

In recent years the idea that the Bible contains hidden messages, called Codes, has come into the awareness of the general public. Such concepts are not new. They are as old as the Bible itself. That magnificent old Book, is not, as some have said "an old fiddle on which any tune can be played." It plays a consistent tune. It tells a consistent story. This story can be found in the plain text and this same story can be found in the various codes. It is the story of redemption through Jesus Christ. It is indeed the greatest story ever told!

The story is played out in types, in prophecies, in symbols, in codes, in numbers, and in the starry heavens. Every night the sky is ablaze with the glory of the great Story Teller, who placed there the whole promise of redemption through Jesus.

The study of these codes has been a lifetime quest which has brought to me a lifetime of joy. And it fills me with even greater joy to be able to share these with others who find delight in the same magnificent quest.

Many students of the Bible feel that we are living in the "end time." It was exciting for me to realize that the codes and symbols also reveal these "end time" events, and provide strong evidence of where we are on the stream of time. Many authors of eschatological concepts

have become shy of revealing dates for the return of Jesus and the "end time" events accompanying His return, because so many published "dates" have failed of their suggested accomplishments. It reflects on credibility. However, let me suggest that the credibility is in the scriptures, not in the expositor.

The evidence of a time-line, bringing us up to the current year and beyond was exciting to me. And I present it as exactly that – evidence! If my interpretation proves to be incorrect, it certainly does not reflect on the credibility of the prophecies.

Through my study of these amazing codes I have become startlingly aware of the time-line for the return of Jesus. It is revealed in the codes. It is there for anyone to see. Much of that time-line is now history – all of which has happened exactly on time. The future looks just as exciting! So I invite you to take this journey with me, and share my joy!

Bonnie Gaunt
February, 1999

Contents

1
The Symbol Code

In the decade of the 90s much has been written about codes in the Bible. With the discovery of the Equidistant Letter Sequence concept by three Israeli mathematicians in 1990, an explosion of books and magazine articles has been written about this phenomenon. Some have eagerly received it as an end-time revelation, while others openly reject it.

When I first heard of the Equidistant Letter Sequence (ELS) Code, I was skeptical, fearing that perhaps it was a modern-day deception. However, I was not against the idea of the Bible containing a code, for I had been studying its Number Code (Gematria) for over thirty years, and had written several books on the subject.

That the Bible should contain a message more subtle than its plain text can be agreed upon by nearly all who read its pages, for it often speaks in symbols. Symbols are, in fact, a form of code, but we are so accustomed to them that we accept them as readily as the plain text. A symbolism is naming something what it is not, in order to describe what it is. The Bible is full of it!

The logical question arises: If the Bible does indeed contain codes, what is their purpose, and what is the message that those codes convey? Do all of the codes reveal a consistent message?

I can answer the question with a resounding "Yes!"

When the codes are deciphered they tell the greatest story man has ever known! And they tell it over and over again, in case we missed it the first time around. It is the story of The Coming of Jesus. The codes tell of His coming as a baby in Bethlehem, of his death on Calvary's cross, and of His glorious return. It is the whole message of the plain text and it is the beautiful and fantastic message of the codes. A time-line is even included, bringing us up to today's events – the time for His return.

The Symbol Code of events covers a span of 6000 years and into the future. As all students of scripture know, the Bible is replete with symbols, but in this chapter I will deal with only one – a lamb.

The first lamb spoken of in the Bible is a dead one. **"And Abel, on his part also brought of the firstlings of his flock and of their fat portions. And the Lord had regard for Abel and his offering,"** (Genesis 4:4).

The meaning of the symbol might be somewhat obscure, but it becomes clearer with the next lamb.

"And Abraham took the wood of the burnt offering and laid it on Isaac his son, and he took in his hand the fire and the knife…And Isaac spoke to Abraham his father and said… 'Behold, the fire and the wood, but where is the lamb for the burnt offering?' And Abraham said, 'God will provide for himself a lamb for the burnt offering.'" (Genesis 22:7,8)

We know the story. Abraham built an altar and then placed Isaac on it. But an angel of God stopped Abraham as he drew the knife to slay his son. **"Then Abraham raised his eyes and looked, and behold, behind him a**

ram caught in the thicket by his horns; and Abraham went and took the ram, and offered him up for a burnt offering in the place of his son."

These events really happened just as the plain text tells us, but they were symbols of the most important event in the history of man. By asking Abraham to offer his only son as a sacrifice, God was saying, in symbol, that He would offer *His* only Son in sacrifice. The act was an encoded message.

And if we missed it the first time, He repeated it. On the last night that the Israelites were in Egypt, God sent the tenth plague. All the firstborn of every household would die. However, the Israelites could substitute for the firstborn a lamb. **"Your lamb shall be an unblemished male a year old…and you shall keep it until the fourteenth day of the same month** (Nisan), **then the whole assembly of the congregation of Israel is to kill it…"**

The Israelites obeyed the instructions, and their firstborn were saved. They sprinkled some of the blood of the lamb around the doorframes of their houses, so that when the death angel came, he would pass over those houses where the blood was displayed. Thus the event came to be known as the Passover.

This event really happened, just like the plain text records it. But it was a symbol. Encoded into the events of that night was the message that One who was represented by the lamb would one day be killed to save those who had been condemned to death.

All men had been condemned to death because of

the sin of Adam. God was sending a message, through symbol, that a substitute for Adam would die in his place, thereby saving those who had been condemned.

And, just in case we missed it, about 1500 years later He sent the Apostle Paul to tell us **"Christ, our Passover, is sacrificed for us,"** (I Corinthians 5:7)

In the meantime God gave the message of this event to His prophets, making it even more plain. Isaiah wrote, **"Like a lamb that is led to the slaughter, and like a sheep that is silent before its shearers, so He did not open His mouth...He was cut off out of the land of the living, for the transgression of my people** *to whom the stroke was due,*** (Isaiah 53:7-8).

When Jesus was thirty years old, He came to His cousin, John, to be baptized. John saw Him coming and exclaimed, **"Behold the Lamb of God who takes away the sin of the world,"** (John 1:29). The symbol of the lamb was now identified with Jesus. What had been told in symbol – in code – had now been given a positive identification.

Three and one half years later, on the very afternoon of Passover, the Lamb of God died. The reality of all that had been told in symbol had now come to pass. Peter stood and watched, and wept. He would later tell the meaning of what he had witnessed. **"...you were not redeemed with perishable things, like silver or gold, from your futile way of life inherited from your forefathers, but with precious blood, as of a lamb unblemished and spotless, the blood of Christ. For He was foreknown before the foundation of the world, but has**

appeared in these last times for the sake of you," (I Peter 1:18, 19).

What had at first been given only in symbol had now become a recognizable reality. The code had been deciphered.

But the story does not end there. Jesus promised that He would come back and take His beloved disciples to be with Him. He said, **"In my Father's house are many dwelling places...I go to prepare a place for you. And if I go and prepare a place for you, I will come again, and receive you to Myself, that where I am, there you may be also,"** (John 14:2, 3).

Just as He has promised, in the prophetic book of Revelation we find the Lamb again. This time the scene is a glorious wedding. **"Let us rejoice and be glad and give the glory to Him, for the marriage of the Lamb has come and His bride has made herself ready. And it was given to her to clothe herself in fine linen, bright and clean, for the fine linen is the righteous acts of the saints,"** (Revelation 19:7, 8).

For nearly 2000 years His disciples have waited for His promised return. They knew that just as assuredly as He promised, so it would one day happen. And John saw the vision of that long-awaited event – the glorious wedding of the Lamb and His bride. He saw it as the fulfilling of all the promises and all the symbols regarding the Lamb. We still wait! Each generation of believers has longed for that promised day when He would return to take them to be with Him, just as He promised. When will He come?

The prophet Hosea hinted that it would be a long period of two prophetic days that His people would wait for His return. **"He has torn us, but He will heal us; He has wounded us, but He will bandage us. He will revive us after two days; He will raise us up on the third day that we may live before Him,"** (Hosea 6:1, 2). But I'm getting ahead of the story...

2
The Number Code

The Number Code is not a new discovery. It has been known by the ancients long before Christ. Its use in the Old Testament manuscripts was called to our attention by Barnabas, the traveling companion of the Apostle Paul. The writings of Barnabas were not included in the canon of scripture that we have today. However, the early church fathers recognized it as authentic. It has been cited by Clemens Alexandrinus, Origen, Eusebius, Jerome, and many others.

Here is what Barnabas told us about the Number Code (Gematria) that is found in the Old Testament.

> Understand therefore, children, these things more fully, that Abraham, who was first that brought in circumcision, looking forward in the Spirit to Jesus, circumcised, having received the mystery of three letters. For the Scripture says that Abraham circumcised three hundred and eighteen men of his house. But what therefore was the mystery that was made known unto him? Mark first the eighteen, and next the three hundred. For the numeral letters of ten and eight are I H. And these denote Jesus. And because the cross was that by which we were to find grace; the note of which is T (the figure of his cross), wherefore by two letters he signified Jesus, and by the third his cross. *(General Epistle of Barnabas VII:10-13)*

Without a bit of orientation into the Number Code, we might not recognize the significance of what Barnabas was saying. He was telling us something of great importance regarding the understanding of scripture.

The scriptures that he was talking about are the manuscripts of the Old Testament. In His day, these had been translated into a Greek version, called the Septuagint, which was the common text then in use. Thus he was referring to an Old Testament text in the Greek language. He said that the letter "I" represented ten, and the letter "H" represented 8, and thus these two numbers represented Jesus because "IH" are the first two letters in the name Jesus. This is correct, however, Barnabas may or may not have known that the numbers 1 and 8 almost always have reference to Jesus, because they are the numbers of Beginning (1) and New Beginning (8), as we will see as we proceed. Jesus was the representative of the Father in all works of creation. John said that **"all things were made by Him and that without Him was nothing made."** And it is through the ransom sacrifice of Jesus that mankind will have a New Beginning. When the glorified Jesus told John **"I am the Alpha and the Omega"** He was really saying "I am the 1 and the 800" for these are the number equivalents for the Greek letters *"alpha"* and *"omega."*

Barnabas also said that the number 300 refers to the cross of Jesus, because the letter "T" has a numeric value of 300, and it is the letter that represents the cross. This also is true. In fact, the number 300 is the addition of the Hebrew letters in the word "ransom" or "atonement"

for this is exactly what He accomplished when He died upon that cross. The number 300 is also the numeric value of the Hebrew word for "crimson" or "red." And, of course it has reference to His blood that was shed when the Roman soldier pierced His side and His blood ran out onto the ground at the foot of the cross. They are not random numbers. They have intended meaning.

Barnabas said it was the significance of the number 318 that caused Abraham to have 318 men of his household circumcised. We have no record that Abraham understood the meaning of the number, other than Barnabas' suggestion. However, I feel it is highly significant that Barnabas suggested the 318 represented Jesus, because it is the numeric value of the word "sun" in Greek *(ηλιος)*. Jesus is often referred to as a great light. He said, **"I am the light of the world."** But there's more!

This number 318 also has reference to Jesus as the Beginner. In Genesis 1:1 we are told **"In the beginning God created the heaven and the earth."** The Hebrew word used here for "God" is *Elohim* – a plural word, denoting more than one. It includes the One who would one day be named Jesus. If we were to add the number equivalents for the two Hebrew words אלהים בראשית, (In the beginning God), the total would be 999. This is represented by a circle, which has neither beginning nor end, eternal. If the circumference of that circle were 999 units, then the diameter would be 318 units. We are talking about the beginning of creation. They are not random numbers. They are telling us precisely what Barnabas suggested: that Jesus is the 1, Beginner, and

the 8, New Beginner, and that **"all things were made by Him."** He was our Maker, which has a numeric value of 300; and He came to earth to pay the price for man's redemption, represented by the 300. Barnabas revealed a great truth!

1 = Alpha, α
800 = Omega, ω
300 = Maker, יצר
300 = Ransom, כפר
300 = Crimson (His blood), כרמיל
318 = Sun, ηλιος
999 = In the beginning God, בראשית אלהים

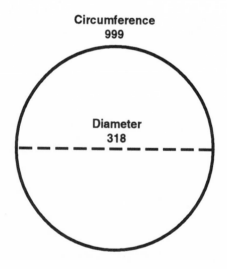

Both the Hebrew and Greek languages – the languages of the Bible, are what is known as "dual character systems." This means they have a meaning of sound

and a meaning of number. These two languages originally did not use numerals. They used the letters of their alphabet as a numbering system. The Hebrew language still uses this numbering system. There are many evidences of it in the Bible. The 119th Psalm, for instance, is divided into 22 sections, and each section is numbered by using a letter of the alphabet. The Hebrew alphabet has 22 letters. Evidence of gematria can also be found in the New Testament, for the number of the beast of Revelation 13:18 was written in the Greek text as χξς', whose number equivalent is 666. The *Textus Receptus*, from which our King James Version was translated used the gematria for this number, as did also the Vatican Manuscript. (It is the only place in the Bible where the Greek letter *Stigma* is used, denoting the number 6.)

The number equivalents of both the Hebrew and the Greek alphabets are listed below. You will notice that there are two numbers missing from the Greek alphabet – 6 and 90. The letters that represented those numbers have been dropped from their alphabet. They were only used as numbers, and not used in the phonetics of their language.

This is the Number Code that has come down to us, basically unchanged from ancient times. It is one of the secret codes that unlocks the treasures and wonders of the Bible. However, it has only been secret because, from time to time down through the centuries, its existence has been forgotten, and it falls from common use. And it is an integral part of the original Hebrew and Greek scriptures – the Word of God.

Hebrew Alphabet

aleph	א	1
beth	ב	2
gimmel	ג	3
daleth	ד	4
he	ה	5
vaw	ו	6
zayn	ז	7
cheth	ח	8
teth	ט	9
yod	י	10
kaph	ך כ	20
lamed	ל	30
mem	ם מ	40
nun	ן נ	50
camek	ס	60
ayin	ע	70
pe	ף פ	80
tsady	ץ צ	90
qoph	ק	100
reysh	ר	200
sin	שׁ	300
tau	ת	400

Greek Alphabet

alpha	α	1
beta	β	2
gamma	γ	3
delta	δ	4
epsilon	ε	5
zeta	ζ	7
eta	η	8
theta	θ	9
iota	ι	10
kappa	κ	20
lambda	λ	30
mu	μ	40
nu	ν	50
xi	ξ	60
omicron	o	70
pi	π	80
rho	ρ	100
sigma	$\sigma\ \varsigma$	200
tau	τ	300
upsilon	υ	400
phi	ϕ	500
chi	χ	600
psi	ψ	700
omega	ω	800

As an example of how gematria works, let's look at the most prominent name in the New Testament – Lord Jesus Christ – spelling it in Greek, just the way it is in the original text. Then we will assign its number equivalents, and add them together to get the total. Then we will do the same thing with its equivalent in Hebrew.

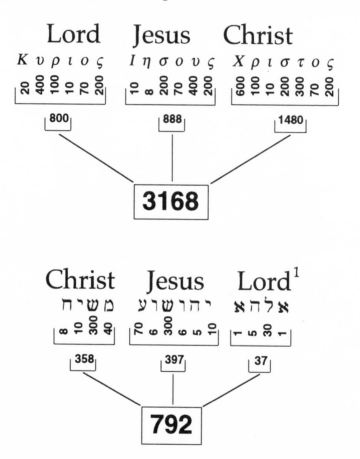

1 Hebrew reads from right to left. There are several other ways of spelling Lord and Jesus in Hebrew, which will be shown later. The above spelling of Lord is from Daniel 4:2

14 *The Coming of Jesus*

The numbers obtained from the Hebrew and Greek gematria for Lord Jesus Christ are impressive. They define the geometry of our earth. The mean diameter of our earth is 7,920 miles, thus a square drawn around it would have a perimeter of 31,680 miles. It was not a coincidence – it was planned by the One who created the earth. It was as if He signed His name to His beautiful work of creation.

Perimeter of Square 31,680 Miles

Mean Diameter 7,920 Miles

Mean Radius 3,960 Miles

Earth is the place of salvation through the Lord Jesus Christ!

3168 = Lord Jesus Christ
792 = Lord Jesus Christ
792 = Salvation, ישועות
396 = Salvation, הישועה

We saw in the previous chapter that the Bible is the *story* of salvation. Here we see that the earth is the *place* of salvation. That story had its beginning in the Garden of Eden. Adam and Eve were created in perfection, in the moral image and likeness of their Creator. In that condition they were given life that would never end – eternity. Adam was made a king, and given dominion over the earth. In the Number Code, that kingdom would have borne the number 1152, for that is the numeric value of Kingdom of God. But it didn't stay that way.

They disobeyed a law of their Creator, and thus a sentence was placed upon them of **"You will surely die."** They were sent out of the beautiful garden, into the untilled earth. From the moment of their sin, Adam lost his dominion, and the days of their dying began to count. Adam had 930 of them.

But before they left, God killed an animal and made from it what the Bible calls **"coats of skin"** to cover their naked bodies. **"Coats of skin"** in Hebrew has a numeric value of 1152. It was a symbolic act, as well as a practical covering for them. It pictured the covering of their now sinful nature, so that they could once again have communion with their Creator. The slaying of the animal is a picture that is carried all the way through man's history down to the offering of the Lord Jesus Christ upon the cross of Calvary. It was through that offering of His life, for the life of Adam, that He opened the way for man to once again enter the Kingdom of God, 1152.

It is worthy of note that the prophecy of Isaiah 53:10 which describes Jesus on the cross – **"It pleased Jeho-**

vah to crush Him, to make him sick" – has a numeric value of 288. Thus the same geometric principle that we saw with the earth, the place of salvation, we now see with this transaction of the salvation of man.

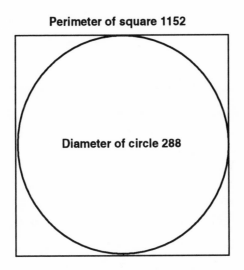

Perimeter of square 1152

Diameter of circle 288

After Adam and Eve were driven out of the Garden of Eden, they began to bear children. The first two, who may have been twins, were Cain and Abel. When they were grown, Cain was engaged in agricultural work, while Abel was a keeper of the flocks.

Both brought offerings of their possessions to God. Abel brought a **"firstling of his flock."** It was a proper and acceptable offering because it pictured the offering that the Lamb of God would make upon the cross of Calvary nearly 4000 years afterward. Thus both Abel, and his offering were a type of Jesus and His offering.

This is clearly shown by the Number Code. The name Abel, as spelled in Hebrew, has a number equivalent of 37. Not only is it a prime number, but its multiples tell the story of salvation through Jesus Christ.[1]

37 = Abel, הבל
37 = Only Son, (Jesus), היחיד
37 = Only begotten, (Jesus), יחידה
37 = Truth, לוא
370 = He has founded the earth (showing His work of creation, ארץ יסדה
370 = My Messiah, במשיחי

Coming down through about 2000 years, we find Abraham on Mount Moriah, building an altar and laying the wood in place for the fire. He knew that God had asked him to offer his only son, Isaac, as a sacrifice. How could he do it! How could he give up the son he loved so much – the special seed of promise that God had given him! His heart was heavy as he lifted the young man to the altar and reached for the knife.

Isaac was as good as dead, when the angel of God called to Abraham and restrained the arm that was wielding the fatal blow. It was then that Abraham saw something moving in the bushes beside him. He looked down, and there, caught in the thicket, was a lamb, a young ram. He took the ram and placed it on the altar in the place of Isaac, and there offered him for a sacrifice.

1 In my previous book, *Jesus Christ: the Number of His Name*, are listed 194 of those names and titles, all multiples of 37.

The scripture says, **"And Abraham went and took the ram, and offered him up for a burnt offering in the place of his son. And Abraham called the name of that place 'The Lord Will Provide,' "** (Genesis 22:13, 14) If we assign the numeric value to each of the words in this verse, they will total 3368. By this number, encoded into the narrative more than 3000 years ago, we know that it is a picture of the offering of Jesus upon the cross of Calvary, for the name Lord Jesus Christ also adds to 3368.

We saw the method by which we added the number values of each of the letters in His name, and obtained the total of 3168. Using the same method, we now obtain 3368 by the second way that "Lord" is spelled in the Greek New Testament.

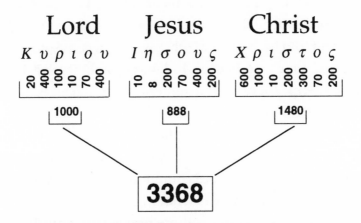

It was no coincidence – it was planned by the Master Mathematician of the universe! He was telling, by the Number Code that He placed into His word, the same story that He told us in the Symbol Code. He was telling us that this act of faithful Abraham pictured God

Himself, offering His only Son on Calvary's cross.

In deep gratitude, Abraham named the mount The Lord Will Provide, which in Hebrew was *Jehovah-jireh*, יהוה יראה. *Jireh* means "will provide" and its numeric value is 216. It was on this same hill, in A.D. 33, that the Son of God offered His life in sacrifice. Yes, the Lord surely provided! He provided a substitute for Adam – His own dear Son, the man Jesus, to pay the price, the death penalty, for the sin of Adam,

The number 216 is one of the sacred numbers in the Number Code, as will be shown later. But for now, let's look at one of its uses.

After the drama on the mount that Abraham named The Lord Will Provide, Isaac was married, and fathered a son whom he named Jacob. Jacob fathered twelve sons. Jacob, on his death bed, called his twelve sons to his bedside, and told each of them what would become of them in future times. To his son Judah, he said, **"Judah is a lion's whelp"** (or cub). The numeric value of *lion*, as used in this statement, adds to 216.

The blessing that Jacob placed upon his son Judah was, in fact, a prophecy that was to reach all the way down through time to the coming of Jesus, the Lion of the Tribe of Judah. Here is what he said.

"Judah, may your brothers praise you, your hand be on the neck of your enemies; may the sons of your father bow themselves to you. Judah is a lion's whelp; my son, you have gone up from the prey; he stoops, he crouches like a lion; and like a lioness, who can rouse him up? The sceptre shall not depart from Judah, nor

the lawmaker from between his feet, until Shiloh come, and the gathering of the people shall be to him. Binding his foal to the vine and his ass's colt to the choice vine, he washes his clothing in wine, and his raiment in the blood of grapes. His eyes shall be dark (sparkling) from wine, and his teeth white from milk."

Some of the language sounds a bit confusing at first, however, it is all prophetic of the coming of Jesus, and its use of the Number Code is outstanding!

The name "Shiloh" is prophetic of Jesus at His return. The name means "the peaceable one" or "peacemaker" or "the one who brings rest." Of this one who would be called "Shiloh" it was said: **"The sceptre shall not depart from Judah, nor a lawmaker from between his feet, until Shiloh come, and the obedience of the people shall be to him."** The prophecy is talking about rulership. Just as the lion is king of beasts, so Judah was to be the father of a kingly line. The first king to come from the line of Judah was King David. His kingdom was a type, or fore-shadow of the reign of King Jesus, who was of the line of Judah, through David. The time for the reign of these two kings, David and Jesus, was skillfully encoded into the prophecy. And its use of the Golden Proportion is magnificent!

The Golden Proportion is the mathematical ratio of 1:1.618, or sometimes simply written as .618. (More precisely it is .618034.) In mathematics, it is called by the Greek letter *phi*, ϕ. It is said to be the most pleasing proportion to the sight, and it is the mathematical growth principle that is used in all creation. It can be seen in the

pattern of the seeds in the sunflower, and in daisies, it can be seen in the seed pattern of the pine cone, in the embryos of all vertibrates, in the swirl of hair on the human head, and in the great galaxies of the starry heavens. That it should be used in the Number Code of the Bible is not surprising, for it is the principle upon which all creation is based.

So let's look at the Hebrew text of this prophecy. Remember, Hebrew reads from right to left, and thus when showing the word-for-word translation, the English must also be read from right to left.

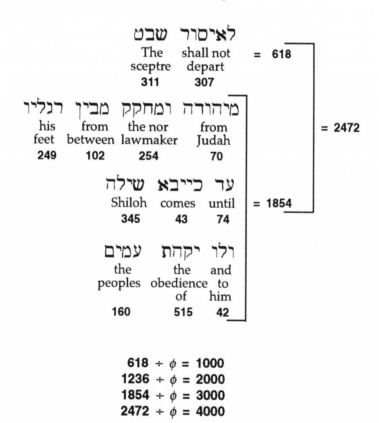

לאיסור	שבט	
The sceptre	shall not depart	= 618
311	307	

מיהורה	ומחקק	מבין	רגליו	
from Judah	the nor lawmaker	from between	his feet	= 2472
70	254	102	249	

עד	כייבא	שילה	
until	comes	Shiloh	= 1854
74	43	345	

ולו	יקהת	עמים	
and to him	the obedience of	the peoples	
42	515	160	

$$618 \div \phi = 1000$$
$$1236 \div \phi = 2000$$
$$1854 \div \phi = 3000$$
$$2472 \div \phi = 4000$$

The number 1236 did not appear in the above text, however, it was included in the list below the text because it is a very important number in the series.

Precisely 1000 years from the year when David was anointed king over all Israel, Jesus was born. He was the long-promised "seed" of David, the Lion of the Tribe of Judah. At His birth it was said that He was the fulfillment of the prophecy of Isaiah 7:14: **"Therefore the Lord Himself shall give you a sign, Behold, a virgin shall be with child and shall bring forth a son; and she shall call His name Immanuel."** Matthew quoted this in relating the events of Jesus' birth. The name Immanuel, Matthew said, means **"God with us,"** $\mu\varepsilon\theta\,\eta\mu\omega\nu\,\Theta\varepsilon\varsigma$, and its numeric value adds to 1236, which is twice the Golden Proportion, or, as is shown on the opposite page, $1236 \div \phi = 2000$. It was precisely 1000 years from King David to the birth of Jesus, and it would be another 2000 years before the second coming of King Jesus.

The appearance of the numbers 3000 and 4000 in the Number Code is also part of the prophecy. There were 3000 years from Adam to King David, and another 1000 to the birth of Jesus, making 4000 from Adam to Jesus. And by counting from King David, there would be 3000 years to King Jesus, and another 1000 to the grand fulfillment of the Millennium, making 4000. But I'm getting ahead of the story again!

The blessing that Jacob placed upon his son, Judah, has another encoded message. He said, speaking of the one to come who would be called Shiloh, **"His eyes shall be dark from wine and his teeth white from milk."** The

Hebrew word translated "dark" really means "sparkling red." Its number value is 108. Again we see the numbers 1 and 8 used in reference to the coming of Jesus. Just as Barnabas had suggested, Jesus is represented by the 1 and the 8, for He is the Beginner and the New Beginner. The "sparkling red" is another way of saying what Isaiah described: **"Though your sins be as scarlet, they shall be white as snow; though they are red as crimson, they shall be like wool."** In Isaiah's prophecy, the words **"they shall be white,"** is only one word in Hebrew. It is ילבינו and its letter-numbers add to 108. It is only through the blood of Christ, shed on Calvary, that our inherited sin of Adam could be taken away, and thus made white. Isaiah again, in his description of the suffering and death of Jesus (chapter 53), said **"He was pierced"** which also has a numeric value of 108. But the grand 1 and 8 are in the words of the angel Gabriel, who told Mary that she would have a son. He said **"He shall be great, and shall be called Son of the Highest, and the Lord God shall give Him the throne of David,"** (Luke 1:32). Its numeric value adds to 10080.

Red (108) is cancelled out by red; or, more correctly, red, placed on red, cancels red. Thus 108 added to 108 equals 216. **"The blood of grapes"** in this prophecy has a numeric value of 216, for it is His blood that cancels the red of sin.

A few more than 200 years after Jacob died, his family, who had multiplied into a very large number of people, living at the time in Egypt, were being enslaved to the Pharaoh. Under the leadership of Moses, they

embarked upon the ambitious endeavor of leaving Egypt and returning to Jacob's homeland, Canaan. Little did they know that the trip would take forty years.

When Moses asked leave from the Pharaoh, the answer was "no." God made Pharaoh a little more willing by sending a series of plagues on the land. After nine severe disasters upon the land of Egypt, the final plague was the death of all the firstborn, both of humans and of cattle. Even Pharaoh's own firstborn son died that night. By this time Pharaoh was willing to let them go.

God instructed Moses to have each household of the Israelites kill a lamb, and sprinkle its blood around the door frames of their houses, so that when the death angel passed by, he would see the blood and save the firstborn of that household alive. Thus, it became known as the Passover. That word, and that event, in the Number Code is marvelous!

The killing of the lamb is a picture of the killing of Jesus; and the saving power of the blood of that lamb pictures the saving power of the blood of Jesus. The Apostle Paul made it unmistakably clear when he said, **"Christ, our Passover, is sacrificed for us,"** (I Corinthians 5:7). 1480 years later (by inclusive counting), on the afternoon of Passover, in A.D. 33, Jesus died on the cross, on the hill that Abraham had named "The Lord Will Provide." And the Number Code tells the story:

1480 = Christ, $X\rho\iota\sigma\tau o\varsigma$
148 = Passover, פסח
148 = Blood, נצה

Soon after they left Egypt and embarked upon their trek through the barren wilderness, the people asked for water to drink. Moses had instructed the people to carry a rock that had been brought with Jacob to Egypt. It was a very special rock which Jacob had anointed many years earlier, when God had confirmed the covenant with him that He would bless his descendants.

When the Israelites complained to Moses that they were thirsty, and there was no water in the desert, God instructed Moses to have the people gather around, and then Moses was to strike the rock. When he did, water came gushing out. It was an abundant fountain of water that not only satisfied the thirst of the people, but all the cattle as well.

Water does not naturally flow from a rock. It was a miracle. But it was for a purpose – more than simply to quench their thirst. That water saved their lives. But Moses had to strike the rock before it would produce the life-giving water. It was a symbol (part of the Symbol Code) of the striking of Jesus with the death blow, and thereby saving the lives of all of Adam's race. The amazing thing is its message in the Number Code!

It is one of the beautiful gems that can be found when studying the Number Code of the Bible. This incident of obtaining water from the rock by striking it, tells the story of the Coming of Jesus, both as the One who would offer His life on Calvary's cross, and as the glorified King Messiah, who sits on David's throne, and brings the water of life to all of Adam's race – the one called Shiloh.

Just as we saw that the mean diameter of the earth, 7920 miles, relates to the place of salvation, ישועת, 792, so salvation was illustrated by the quenching of the thirst of the people when they cried for water. **"They thirsted not in the desert,"** (Isaiah 48:21), ולא צמאו בחרבות, 792.

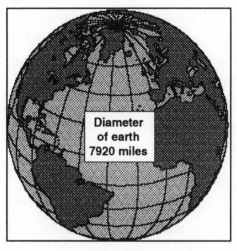

Perimeter of square 31680 miles
3168 = Lord Jesus Christ

Mean diameter of earth 7920 miles
792 = They thirsted not in the desert.

These amazing numbers tell the beautiful story of salvation through Jesus Christ, as illustrated by Moses striking the rock, causing the water to gush out. The Apostle Paul confirmed the meaning of the Rock, when he said, **"...and all drank the same spiritual drink, for they were drinking from a spiritual Rock which followed (accompanied) them; and the Rock was Christ,"** (I Corinthians 10:4) Again the Number Code leaves no

doubt concerning the identity of the "spiritual Rock," πνευματικης πετρας, 1800. The 1 and the 8 again – they are symbolic of the Beginner and the New Beginner, Jesus Christ. And using the same geometric principle shown above for the earth, we find the identification emphasized. For when Jacob had anointed the stone, after having received the confirming of the covenant, he said, as he poured oil over it, **"The Stone shall become the House of God,"** (Genesis 28:22). The numeric value of the text is 592.

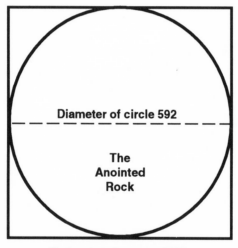

Perimeter of square 2368
Jesus Christ, *Ιησους Χριστος,* = **2368**

Diameter of circle 592
The Stone shall become the House of God = 592

King David set the story to song, and he said, **"He opened the rock and the waters gushed out; they ran in the dry places,"** (Psalm 105:41). The gematria for the

Hebrew text, as David wrote it, adds to 1480. The title, Christ, which means "anointed," has a numeric value of 1480.

In the SymbolCode, the striking of the rock, and the water gushing out, represents the broken humanity of Jesus as He hung on the cross. It was a free offering of Himself. He not only died to save all of Adam's race, but His death also made atonement for Israel's condemnation for having broken God's Law. When He comes again to save Israel, in Armageddon, and defeats Israel's enemies, He will come as Shiloh, and **"to him will the gathering of the people be."** It will be the gathering of Israel to their Messiah, the Anointed One. The Number Code tells the beautiful story. The name Shiloh has a numeric value of 345. The name Moses, who, by striking the rock, represented Jesus offering His life, has a numeric value of 345. **"Water out of the Rock,"** (Numbers 20:8) has a numeric value of 345. **"My Servant David** (Jesus) **shall be King over them,"** (Ezekiel 37:24), has a numeric value of 345. And the time for this to take place – **"At the revelation of the Lord,"** (II Thessalonians 1:7), when Jesus comes with His bride, to conquer Israel's enemies, also has a numeric value of 3450. There is no mistaking the intended meaning, encoded into the scriptures by the master hand of the Creator. He was telling us that just as Moses struck the rock and water gushed out, so will Jesus offer Himself upon Calvary's cross, and thereby save all mankind (and especially Israel); and that He will come again and take His position as King on the throne of David, when He will be the promised Shiloh,

who saves Israel and gathers them once again unto Himself. Here are the numbers:

345 = Water out of the Rock, מים מן הסלע
345 = Moses, משה
345 = Shiloh, שילה
345 = My servant David shall be King over them,
 עבדי דוד מלך עליהם
3450 = At the revelation of the Lord, εν τη
 αποκαλυψει του κυριου

If we were to count 3450 years from the time the Law Covenant was given to Israel, or more correctly from the time they broke that covenant and needed redemption (and possibly from the year that Moses struck the rock to get water) it would bring us to the year 5766 on the Hebrew Calendar. It is our year 2005-2006. Was the date for Shiloh to gather the people also encoded into the text? But I'm getting ahead of the story again.

After the death of Moses, a man named Joshua was chosen to lead the Israelites into the land of Canaan. They had been in the desert wilderness for forty years after they left Egypt. The name Joshua is spelled several ways in the Hebrew text, and sometimes its translation into English is spelled Jeshua, but the meaning is the same regardless of the spelling. It means *Saviour*. Its Greek equivalent is the name Jesus. Joshua led the Israelites across the river Jordan, and into the land that had been promised to them. In the Symbol Code, the Jordan river is a symbol of death. Thus Joshua – *Saviour* – saved his

people from death and led them safely over into Canaan, just as Jesus – *Saviour* – has saved His people from death and promised that they would be restored to life.

In the New Testament, the name Jesus is spelled *Ιησους*, which has the numeric value of 888. It is the number 8, the number of New Beginning, raised to its triplet form. This concept is often seen in the gematria of the Bible, and when a number is raised to its triplet, it is referring to its full and ultimate meaning or accomplishment.

Jesus

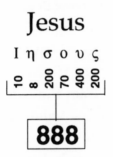

Just as Joshua saved his people by safely leading them across the Jordan, so we find that the word *save*, as it is spelled in Greek, is simply the one Greek letter *η*, which has the number value of 8. Raised to its triplet we find the Saviour of mankind, Jesus, 888.

The fish has always been the symbol of Christianity, and even today we still wear the fish as a charm around the neck; and today we even see many as bumper stickers. The word *fish* in Hebrew is ‏דאג‎, which adds to 8.

Just as Noah and his family were saved from death by being in the Ark, so the family of Adam well be saved

from death by being in Jesus. The Apostle Peter made a similar analogy when he said, **"...the longsuffering of God waited in the days of Noah, while the ark was preparing, wherein a few, that is, eight souls were saved by water,"** (I Peter 3:20). Not only did the eight persons who were saved on the Ark indicate that it was a New Beginning, but the name Jesus, 888, is shown in the message of the text. **"...an ark, wherein a few, that is, eight souls were saved by water"** has a numeric value of 888. By the Number Code we can find the message: the saving of Noah's family (a New Beginning) by means of the Ark, represented the saving of Adam's family (a Beginning) by means of Jesus, 888, which will mean for them a New Beginning. Jesus, Himself, referred to this concept when He said **"I am the life,"** (John 14:6), ειμι η ζωη, which has a numeric value of 888.

His mission, as the Saviour, was indicated in the prophecy of His birth. **"Behold, a virgin shall conceive and bear a son, and they shall call His name Immanuel, which being interpreted, is God With Us,"** (Matthew 1:23) The Greek text of this, as quoted by Matthew, has a numeric value of 8880. His work of bringing salvation was prophesied by Isaiah when he referred to Jesus as **"the Salvation of our God,"** (Isaiah 52:10), which also has the numeric value of 888.

Isaiah also told of His death, and of the mock trial, and the scourging that He received at the hands of the Roman soldiers. He said that Jesus would be led as a lamb to the slaughter, but that He would not open His mouth in His own defense. **"As a lamb to the slaughter**

He was led, and as a ewe before her shearers," (Isaiah 53:7) also has a numeric value of 888.

Following the entering of the land of Canaan, under the leadership of Joshua, the Israelites were governed by Judges for several hundred years. But they observed that other nations had kings to rule over them, and so they begged for a king. Saul was anointed to be their first king, but it was not to last, for many reasons, one of which was that he was not of the line of Judah, who had been promised the rulership. So Samuel, who was acting as Judge at that time, was sent by God to the home of Jesse to anoint one of his sons to be the King of Israel. Jesse was of the line of Judah. Jesse called seven of his sons to be presented to Samuel, but none were acceptable as the new king. Then Jesse called his 8th son, a young boy named David. God indicated to Samuel that this was the one. David not only had the qualifications, he had the right number, for he was the 8th.

Upon the death of Saul, David took his position as king over the small country of Judah, whose capital city was Hebron. After a few years, the people of the northern part of the country, who had called their nation by the name of Israel, came to David and desired that he rule over them also, unifying the nation into one soverrnity. **"And all the elders of Israel came to the king to Hebron, and king David made a covenant with them in Hebron before Jehovah; and they anointed David as king over Israel,"** (II Samuel 5:3). The year was 1002 B.C., exactly 1000 years before the birth of Jesus, and 3000 years before the antitypical David (Jesus) would take

his place as the King on David's throne.

This introduces us to two new numbers – 504 and 528. Both numbers tell of the kingship of David, and the prophetic kingship of Jesus, upon the throne of David.

In the text quoted above, is the key phrase, **"and they anointed David as king,"** וימשחו דוד למלך, which adds to 504.

In the prophecy of Amos, is found a beautiful promise of the time when David's throne is restored, and the breach between the two nations of Judah and Israel will be healed, just as it was healed during the days of David's reign. **"In that day will I raise up the tabernacle of David that is fallen, and close up the breaches thereof; and I will raise up his ruins, and I will build it as in the days of old,"** (Amos 9:11 KJV) When we add the numeric values of the letters in **"the tabernacle of David,"** סכת דויד we find 504. And we know who the repairer of the breach is, for it has been given to us in Isaiah 58:12: **"...and you shall be called The Repairer of the Breach, the restorer of paths to live in."** It is Jesus, when He comes to take His authority as king on David's throne. Isaiah said this would be the time for Israel when **"your light shall break as the dawn and your healing shall spring up quickly,"** (Isaiah 58:8) He used the other important number pertaining to the time when King Messiah will reign – 528. The Hebrew word translated **"as the dawn,"** כשחר, has a numeric value of 528.

Isaiah also spoke of the time when Israel, having been ransomed, will return. He said **"The ransomed of the Lord will return, and come with joyful shouting to**

Zion, with everlasting joy upon their heads. They will find gladness and joy, and sorrow and sighing will flee away," (Isaiah 35:10) His use of the term **"the ransomed of the Lord will return,"** פדויי יהוה ישבון, adds to 504. It will be the time when Jesus is King on David's throne. We find the same identification number used in the book of Revelation, when describing that kingdom. **"The kingdom of our Lord and of His Christ,"** (Revelation 11:15) has a numeric value of 504.

The Number Code of the Bible, its gematria, has another function, as well as addition – the numbers can also be multiplied. When we do this, we find confirming evidence that Jesus is the promised Shiloh who brings salvation to Israel. Here are some examples of multiplication of the numeric values of the letters.

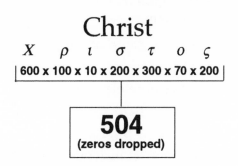

Christa

X ρ ι σ τ ο ς

| 600 x 100 x 10 x 200 x 300 x 70 x 200 |

504
(zeros dropped)

Others by multiplication are:

504 = Until Shiloh comes, עד כי-יבא שילה
 (Genesis 49:10)

504 = Saviour, מושיע

504 = Seventh day (when Shiloh comes)
 יום השביעי

Isaiah prophesied of Jesus, **"He shall be a father to the inhabitants of Jerusalem and to the house of Judah. And the key of the house of David I will lay on his shoulder; so he shall open, and no one shall shut; and he shall shut, and no one shall open,"** (Isaiah 22:21, 22)

Obviously, if He has the "key" to the house, He can unlock it and enter. The "house of David" was David's position as king. And when Jesus returns, He has the key of David, and possession of the house.

In the book of Revelation, Jesus identified himself as the one having this key. **"He that hath the key of David, he that openeth, and no man shutteth; and shutteth, and no man openeth,"** (Revelation 3:7).

"The Key," מפתח, has a numeric value of 528. And, as we have seen, the time when this is to take place is also encoded with the number 528, for the Hebrew word for **"as the dawn,"** כשחר, has a numeric value of 528, having reference to the dawn of the Millennial day, the great thousand years which will follow earth's 6000 years since Adam. But the time element is emphasized in a prophecy of Malachi, where **"the day of His coming,"** רמי את-יום בואו, adds to 528.

Remember the stone which Jacob anointed? He said of this stone that **"it shall be God's house,"** בית אלהים יהיה. It adds to 528. As we have seen, that stone represented the Saviour, just as that same stone saved the lives of the people of Israel when Moses was told to strike it, and the life-giving water came out.

The prophet Haggai, who wrote at the time of the building of the second temple, recorded a message which

he had received of God regarding a future temple that would be greater than the one they were then constructing. The message was: **"Yet once, it is a little while, and I will shake the heavens and the earth and the sea and the dry land. And I will shake all the nations, and the desire of all nations shall come. And I will fill this house with glory,"** (Haggai 2:6, 7). **"The desire of all nations shall come"** has a numeric value of 528. It is referring to the coming of Jesus. Some have interpreted this text as meaning that the desire of all nations is peace; however, according to ancient Hebrew tradition, the title "desire of nations" was always a reference to their hope of a coming Messiah. The same kind of language was used with the phrase "the desire of women" – which has nothing to do with sexual desire, as some claim, but the ancient Hebrew tradition was the hope of every young girl that she would be the one to give birth to the Messiah. Thus He is the "desire of nations" as well as "the desire of women." And the Number Code confirms the "desire of nations" as being the Messiah, by its value of 528.

Jesus, at "the day of His coming," (528), will possess "the key," (528) of the house of David. He will be the long sought "desire of nations," (528). He will be the king, $\beta\alpha\sigma\iota\lambda\epsilon\iota o\varsigma$, (528) to rule on David's throne. And it will happen "as the dawn" (528) of earth's great Millennium arrives. Of that glorious dawn, the prophet Malachi said, "The Sun of Righteousness shall arise with healing in his wings." It is none other than Jesus Christ.

The great event, The Coming of Jesus, both as the

baby born in Bethlehem, and as the glorious King on David's throne, is beautifully illustrated by the Golden Proportion – its Golden Rectangle and the Golden Spiral that is inscribed within it. Let's begin with a square whose perimeter is 5280.

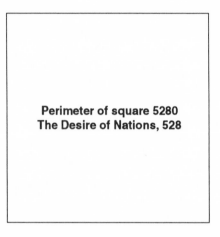

Perimeter of square 5280
The Desire of Nations, 528

Now project from that square its Golden Rectangle, and inscribe within the rectangle its Golden Spiral. The numbers it produces are amazing!

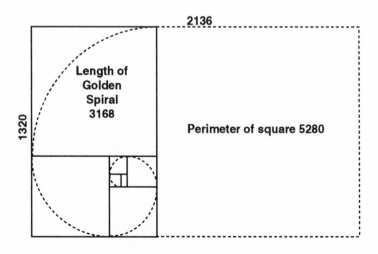

We have seen the meaning of the number 528, and we have seen that 3168 is the number equivalent for the name Lord Jesus Christ. And the other two numbers in this Golden Rectangle are just as spectacular! It was designed by the Master Mathematician of the universe!

The large rectangle on the opposite page has a long side of 2136 and a short side of 1320. Let's start with the short side.

The first coming of Jesus was as a baby, born of a virgin, just like the prophecies had foretold. Mary, who had just received the message from the angel Gabriel that she would give birth to One who would be called the Son of God, went to visit her cousin, Elizabeth. The greeting that Elizabeth gave to Mary was: **"Blessed art thou among women, and blessed is the fruit of thy womb,"** (Luke 1:42). Elizabeth knew something great was happening. But the account plainly says that she was led of the Holy Spirit to say those words. She probably did not realize that encoded into her greeting to Mary was a great truth. The words **"the fruit of thy womb,"** καρπος της κοιλιας, have a numeric value of 1320 – the number we saw on the short side of the Golden Rectangle.

The beauty of this number is that it is also the number for *man*, ανθρωποις, 1320. Jesus had come to be a perfect man – the exact counterpart of the man Adam. He was not only the Son of God, He was also the Son of Man, a perfect man, the second Adam. His mission was to take upon Himself the death penalty that Adam had incurred when he sinned, and thereby provide life for all of Adam's race.

But He was also the one who would come again as a conquering King – the rightful heir to the throne of David. (Mary was of the line of David.) He was the One who had been pictured in the dream that Daniel had interpreted for Nebuchadnezzar. He was the little Stone that was cut out of the mountain that had struck the huge metal image on its ten toes, and caused the whole thing to crumble into fine dust that was blown away by the wind. Then that Stone began to grow, and it grew till it filled the whole earth. That stone is Jesus. And when He returns He will strike the Gentile powers on their ten toes (the revived Roman empire), and it will all crumble and be blown away, never to return. But His kingdom will grow until it fills the whole earth.

In the book of Daniel we find the words, **"the stone cut out of the mountains,"** אבן אתגזרת מטורא, and its numeric value is 1320.

Thus we find that the short side of this remarkable Golden Rectangle represents Jesus, coming as a baby, a perfect man, the exact counterpart of Adam, to take upon Himself the death penalty that was Adam's; and He comes a second time to be the King on David's throne, to overthrow the kingdoms of this world, and eventually to fill the whole world with His kingdom.

Now let's consider the long side of this marvelous Golden Rectangle. It bears the number 2136. It pictures the time when He comes as King, and accomplishes the work of filling the whole world with His kingdom.

In Isaiah 11:10 we find the prophecy, **"And it shall be in that day that the root of Jesse (Jesus) shall stand**

as a banner of the people." It has a numeric value of 2136.

And in that same "day," the great thousand-year day of earth's great Millennium, the beauty of that Kingdom will be the blessed reality to be enjoyed by mankind. To Israel first, and then through them to all the world. It is stated as a time of "new wine" and "milk and honey." The text reads, **"And it will be in that day, the mountains shall drop down new wine and the hills shall flow with milk, and all the streams of Judah shall flow with waters,"** (Joel 4:18). This beautiful promise has a numeric value of 2136.

The Apostle Paul described this One who will reign as King of kings and Lord of lords. He said, **"...until the appearing of our Lord Jesus Christ: which in His times He shall show the blessed and only Potentate, the King of kings, and Lord of lords,"** (I Timothy 6:15). The title **"the blessed and only Potentate,"** by the Number Code, has the value of 2136.

Continuing the story told by the Number Code, we find a prophecy of Micah that also uses the Golden Proportion in telling us about the birth of Jesus, and where He would be born. **"And you, Bethlehem Ephratah, you who are little among the thousands of Judah, out of you shall He come forth to Me to be ruler in Israel, and His goings forth have been from of old, from the days of eternity,"** (Micah 5:1, 2).

In the Hebrew text, this wording is turned around from our way of speaking, and it reads, **"And you, Bethlehem Ephratah, least."** It adds to 1958. The num-

ber seemed to have no apparent meaning in the Number Code. But I was struck by the fact that when this prophecy was quoted by Matthew, in the New Testament, it again added to 1958. So I investigated. Here are the two texts and their number equvalents:

1958 = And you, Bethlehem Ephratah, least, צעיר
ואתה בית-לחם אפרתה

1958 = You, Bethlehem in Judea, συ εν βηθλεεμ της
Ιουδαιας

Out of curiosity, I divided 1958 by the Golden Proportion, and to my surprise and delight, the answer is 3168 – the name Lord Jesus Christ. But the number 3168 also gives the location. The little town of Bethlehem is at 31.68° N. latitude.

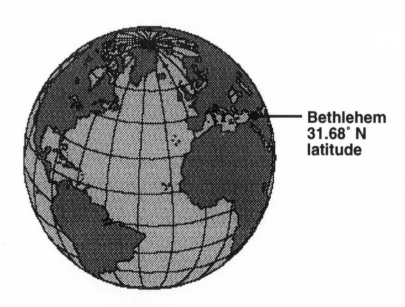

Bethlehem
31.68° N
latitude

Another surprise was in store when I tried multiplying 1958 by the Golden Proportion. 1958 x .618 produces 1210, which is the numeric value of **"She shall bring forth a Son,"** (Matthew 5:1). It hardly seems to be a coincidence.

And then, when checking this with my chronology charts, the number appeared again. If my counting is correct, there appears to be 1958 years from the birth of Abraham[1] to the birth of Jesus. Abraham was the one who offered his son in sacrifice, but God provided for him a young ram instead, all of which pictured the whole purpose for which Jesus came.

3168 = Lord Jesus Christ, *Κυριος Ιησους Χριστος*

3168 = The Son of Man, *η υιου του ανθρωπου*

3168 = Mediator between God and man, *μεσιτης Θεου και ανθρωπων*

It has been shown (page 19) that the title Lord Jesus Christ also adds to 3368, when Lord is spelled with a final *υ* instead of the usual final *ς*. A difference in the final letter of a word is characteristic of the Greek language, and we are accustomed to the idea because many of our English words do the same – such as, "child" becomes "children" when there are more than one. In Greek, the position of the noun in the sentence can make a difference in its ending. When the word "Lord" is

1 The date of the birth of Abraham is not clear in the Genesis record, but can be supported by other chronological cross referencing. The ancient Book of Jasher disagrees with the Genesis record regarding date of the birth of Abraham.

spelled with a final υ its numeric value becomes 1000. Thus making "Lord Jesus Christ" add to 3368.

The name Jesus Christ also appears in the Greek text spelled with different ending letters. The name Jesus sometimes adds to 888 and sometimes it adds to 688. Likewise the title Christ sometimes adds to 1480 and sometimes to 1680. It is interesting that when 888 is used for Jesus, 1480 is always used for Christ, giving a total of 2368. And when 688 is used for Jesus, 1680 is always used for Christ, still giving a total of 2368.

In the prophecies regarding the coming of Jesus as the rightful heir to the throne of David, sometimes He is called The Branch. It is illustrative of the fact that He is of the line of David. He is the promised Branch that will grow out of David's line. The illustration is confirmed by the Number Code.

In Zechariah 6:12 we find the prophecy: **"The Man whose name is The Branch, He shall grow up out of His place, and He shall build the temple of Jehovah."** The Hebrew text has a numeric value of 2368. The number identifies The Branch as being one and the same as Jesus Christ, whose number is 2368.

Isaiah elaborated on this same illustration when he said, **"In that day will the Branch of Jehovah be beautiful and glorious, and the fruit of the earth for pride and for glory for the survivors of Israel,"** (Isaiah 4:2). When we add the number equivalents of each of the letters in this text, they will total 3368, which is one of the numbers we find in the New Testament for Lord Jesus Christ. These two texts, using the same illustration of

The Branch, have a numeric value that positively identifies Him as Jesus Christ. It is not a random coincidence. These numbers were encoded into the text by the One who gave the message to these prophets. But being the Master Mathematician that He is, we are not surprised to find also encoded within this text in Isaiah, the number for Jesus, 888, and the number for Son of Man, 2960.

$$296 = \text{The Branch of Jehovah, beautiful}$$
$$296 = \text{and the fruit}$$
$$+\ \underline{296} = \text{of the earth}$$
$$888$$

2960 = Son of Man, $\upsilon\iota o\varsigma\ \tau o\upsilon\ \alpha\nu\theta\rho\omega\pi o\upsilon$ (Matthew 8:20)

296 = Only begotten, $\mu o\nu o\gamma\varepsilon\nu\eta$

296 = He shall appear in His glory, נראה בכבודו
(Psalm 102:16)

888 = Jesus, $I\eta\sigma o\upsilon\varsigma$

As mentioned previously, the fact that His number is 8 raised to its triplet, indicates that He is the full embodiment of all that is promised in the New Beginning. It is only through Him that we have the opportunity for a New Beginning. When He said **"I am the alpha and the omega"** He was saying "I am the 1 and the 800 – I am the Beginner and the New Beginner."

The amazing Number Code of the Bible even carries this concept of 8 one step further, as if perhaps we had missed the message – now it emphasizes it. His reign

on David's throne is a New Beginning – earth's great Millennium – but there is an even more grand and glorious New Beginning, yet awaiting man. It is the Great Eighth Day, following the Millennium. We are told that by the end of the Millennium, all the enemies of His righteousness will be defeated.

The Apostle Paul told us, in I Corinthians 15:25, **"He must reign until He has put all enemies under His feet."** What a grand demonstration of the Number Code! This statement by Paul has a numeric value of 8888.

3
The ELS Code

ELS is an acronym for Equidistant Letter Sequence. The concept is the spelling of significant words and names by an equidistant spacing of their letters. The concept is not new to those who work with codes and coded messages. Neither is it new to those who study the Bible. Before the age of the computer, searching for such codes was a monumental task. However, there were those who tried it, and with a measure of success.

One of the noteable researchers into the ELS Code is Yacov Rambsel, who searched for the name Jesus in the Hebrew scriptures. Much of his work at the beginning was without the aid of a computer. His book, *Yeshua*, is a marvelous work.

In 1990, three mathematicians, Doron Witzum, Yoav Rosenberg, and Eliyahu Rips, of the Jerusalem College of Technology and the Hebrew University, working with the concept of equidistant letter sequences, developed software that would assist in the search. They uncovered some amazing facts, and gave the world a whole new approach to the ancient scriptures.

Since the publishing of their findings, a number of books have been written showing the validity of the ELS concept. It is not my purpose here to repeat the results of their research, which, in some cases, is awesome! In this chapter, I hope to focus on one concept – the coming of

Jesus, and His work of bringing salvation to man. Since this is the prominent theme of the plain text, it seems reasonable that it would also be the theme of the encoded text. Neither is my work in this area exhaustive. In fact, I have merely scratched the surface of a vast and awesome subject.

Primarily I want to show the encoding of the name Jesus into the ancient text, and show, by its placement in the plain text, its beautiful story of salvation.

The name Jesus is the Greek form of the Hebrew, Joshua, or the Aramaic, Jeshua. The name means "Saviour." This name in the Old Testament is primarily spelled three ways. Each of those three spellings has its special significance. Their spelling, and their gematria is as follows:

$$397 = \text{יהושרע}$$
$$391 = \text{יהושע}$$
$$386 = \text{ישרע}$$

The first spelling – יהושרע – bearing its number 397, clearly shows its connection with Jesus' own identification of Himself. In Revelation 1:17 He said, **"I am the First and the Last."** In the Greek text it is $\varepsilon\gamma\omega\ \varepsilon\iota\mu\iota\ o\ \pi\rho\omega\tau o\varsigma\ \kappa\alpha\iota\ o\ \varepsilon\sigma\chi\alpha\tau o\varsigma$, and it adds to 3970.

The second spelling – יהושע – bearing its number 391 shows his work of salvation. For the Hebrew word for salvation, ישעה, *yeshuwah*, meaning *salvation, deliverance, save*, has a numeric value of 391.

Both יהושע and ישע are exciting, because they bear a relationship to the number seven in both the Old and New Testaments.

386 = Jesus, ישע 397 = Jesus, יהושע

386 = Seven, επτα 397 = Seventh, השביעי

The Hebrew word for seven is שבע, *sheba*. It is from the root *shaba*, which means *complete, full, satisfied, satiated*. This is why we often use the number 7 to represent completeness or perfection. This word *shaba* also has reference to an oath – particularly an oath that was sealed with seven sacrifices.

God's covenant with Abraham was sealed with an oath *(shaba)*. That covenant was not only a land grant, but it was a promise that Abraham would have a son who would bring blessing to all mankind. That son was Isaac, the son whom he offered in sacrifice on the hill he named "The Lord Will Provide." It pictured the offering of Jesus, on that same hill. Jesus is the fulfillment of the oath *(shaba)*. His return as King Messiah at the beginning of the great seventh day *(sheba* or *shebee)* will fulfill the promise of a blessing for all mankind, by the establishing of His kingdom.

Because of the connection of His name and His work with the number seven, I was curious to find what might be encoded into the ancient text by a skip-7 sequence.

The name יהושע is found in a skip-7 sequence in Numbers 27:17. The setting for the text is the time when the Israelites, under the leadership of Moses, had come

to the end of their forty years in the wilderness, and God was going to lead them over into the promised land. But He had told Moses that he would not be the one to lead them because he was about to die. So God told Moses to appoint another leader. That leader was Joshua. The text reads: **"And Moses spoke to Jehovah, saying, Let Jehovah, the God of the spirits of all flesh, appoint a man over the congregation, who may go out before them, and who may lead them out, and who may bring them in, so that the congregation of Jehovah may not be as sheep which have no shepherd."** And in the very next verse, God told Moses to appoint Joshua.

Within this instruction to appoint Joshua, encoded by a skip-7 sequence, is the name יהושע. It has a two-fold meaning. It is the name of Joshua and the name of Jesus, hidden in the instructions.

Joshua was the appointed leader to safely take the Israelites across the Jordan and into the promised land of Canaan. The Jordan pictures death, and entering Canaan represents a resurrection from death. Jesus, the antitypical Joshua, whose name means saviour, also leads His people through death and into a resurrection. This was the whole purpose of His coming to earth and dying on Calvary's cross – to pay the required price for Adam's sin – death – and thereby release all who were under sin's condemnation.

This means of salvation through Jesus was encoded into the text more than three thousand years ago by a skip-7 sequence. And its fulfillment will become an accomplished fact during earth's great seventh day, the

Millennium. I marvel at the precision of the Word of God.

This resurrection on the great seventh day was pictured by the event of Elisha raising to life a young boy who had died, the son of a Shunammite woman. The story is found in II Kings 4. Elisha lay on the body of the dead boy and gave him mouth-to-mouth resuscitation (although it was a miracle because the boy had been dead too long for this kind of attempt at resuscitation to be effective). The boy sneezed seven times, and opened his eyes. It is a picture of Jesus breathing the breath of life into dying humanity, during the great seventh day. And encoded into verse 29, by a skip-7 sequence, is the name ישוע, *Jesus*. It is a powerful hidden message, assuring us that Jesus is indeed our Saviour and will save us from the death penalty incurred by Adam's sin.

Another encoding of the name of Jesus by a skip-7 sequence can be found in Isaiah 12. I will quote from the NIV translation because it is more in keeping with modern English. **"Surely God is my salvation; I will trust and not be afraid. The Lord, the Lord, is my strength and my song; He has become my salvation. With joy you will draw water from the wells of salvation. In that day** (Millennial day) **you will say: Give thanks to the Lord, call on His name; make known among the nations what He has done, and proclaim that His name is exalted."**

Encoded within this beautiful text by a skip-7 sequence is the name יהושע, *Jesus*. It is identifying the One who will bring salvation during the great seventh day. And the event pictured is the Feast of Tabernacles,

during which they drew water while they chanted **"With joy shall ye draw water from the wells of salvation."** Each of the seven feasts of Israel pictured a specific event in the plan of God for the salvation of man. The Feast of Tabernacles was a seven-day event, which pictured the great seventh day, the Millennium. The words **"Wells of Salvation"** מעיני הישועה, have a numeric value of 576. It is suggested that earth's great Millennium will begin in the Hebrew year 5760. Evidence for this will be shown in chapter five.

In Psalm 145 David paints a word picture of the Millennium and the joy that will come to man through salvation. In verses 11 through 13 he says **"They will tell of the glory of your kingdom and speak of your might, so that all men may know of your mighty acts and the glorious splendor of your kingdom. Your kingdom is an everlasting kingdom, and your dominion endures through all generations."** Then, after several similar expressions of praise, David summed it up by saying, **"My mouth will speak in praise of the Lord. Let every creature praise His holy name for ever and ever."** Within this last summary verse, we find encoded with a skip-7 sequence the name ישוע, *Jesus.* The plain text speaks of **"His holy name"** and the encoded text tells us the name is Jesus.

There are several other places where David gives thanks for salvation, and the name of Jesus is encoded within the text. But I want to pass on to some of the scriptures that give a positive identification of just who He is. One such text is the event of the birth of Samson

in Judges 13.

Samson's mother, who had never conceived a child, was told by an angel that she would give birth to a son. She was told that this child would be a Nazirite. She was so disturbed by this announcement of the angel, that she told her husband Manoah what he had said. The next day when the angel appeared again, she ran to get her husband. After talking with the angel, Manoah asked for his name. The angel replied, **"it is Wonderful."** It is the same name that was prophesied in Isaiah 9:6 to be one of the names of the Messiah – **"His name shall be called Wonderful, Counselor, the Mighty God, the Everlasting Father, the Prince of Peace."**

It is suggested that this angel who spoke with Manoah and his wife, was indeed the pre-human Jesus. And He is identified in verse 9 by a skip-7 sequence. Encoded into that verse is the name יהושע, *Jesus.*

Jesus is again identifed by a double-7 sequence in Leviticus 23:12 & 13. In this text Moses was given the law of the Wave Sheaf offering, which was to be done on the third day from the killing of the Passover lambs. This offering consisted of the firstfruits of the barley harvest, as well as the offering of a lamb. It is a picture of the third day from the killing of the antitypical Passover Lamb, Jesus, when He rose from the dead and presented Himself to the Father. He was the great antitypical Wave Sheaf offering. He was the firstfruits of the barley harvest. This positive identification is confirmed by the appearance of His name in a double-7 skip sequence in the text. **"On the day you wave the sheaf, you must sac-**

rifice as a burnt offering to the Lord a lamb a year old without defect, together with its grain offering..." Encoded into the text is the name יהושע, *Jesus.*

There are many such identifying references to Jesus by an ELS of skip 7, but I want to mention just one more. It is the offering of the Red Heifer. There is disagreement among students of the scriptures regarding the meaning of the offering of the Red Heifer. However, Barnabas, the associate of the Apostle Paul, in his epistle states its meaning very clearly. He says:

"But what type do ye suppose it to have been, where it is commanded to the people of Israel, that grown persons in whom sins are come to perfection, should offer an heifer, and after they had killed it should burn the same. But then young men should take up the ashes and put them in vessels; and tie a piece of scarlet wool and hyssop upon a stick, and so the young men should sprinkle every one of the people, and they should be clear from their sins. Consider how all these are delivered in a figure to us. *This heifer is Jesus Christ."* (Barnabas 7:1-4)

Now let's go to the Old Testament and find that to which Barnabas makes reference. It is found in Numbers 19. **"Tell the Israelites to bring a red heifer without defect or blemish and that has never been under a yoke... the heifer is to be burned ... the priest is to take some cedar wood, hyssop, and scarlet wool and throw them into the burning heifer ... a man who is clean shall gather up the ashes of the heifer and put them in a ceremonially clean place outside the camp. They shall**

be kept by the Israelite community for use in the water of cleansing; it is for purification from sin ..."

The whole 19th chapter of Numbers contains instructions for purification with the ashes of the red heifer. And verse 8 contains, by a skip-7 sequence, the name ישוע, *Jesus*, identifying the One whom this heifer represents. And the purification rites were to take place on the third and on the seventh day. Having done this, the person is declared clean on the seventh day. The third day from the first coming of Jesus is earth's great Millennium – which is also the seventh day from Adam. It is the time of cleansing, and by its end, man will have been fully cleansed from the effects of Adamic sin.

These are just a small sampling of the appearances of the name "Jesus" in the Old Testament which can be found hidden by the ELS Code. When I first heard of this code, I was skeptical, as was just about everyone. But then I realized that over thirty years ago, when I first heard of gematria I was also skeptical. I feared it was of the occult, and something to be avoided when dealing with the sacred word of God. However, during these many years of in-depth study of gematria in the Hebrew and Greek texts of the Bible, the evidence for its authenticity has been overwhelming. There is no way it could be some grand colossal coincidence. And there is also no way that the human writers of the text could have knowingly put it there, because the sixty six books of the Bible were written by men, most of whom did not even know each other, over a period of more than 2000 years. They could not have collaborated on a secret code. After much

study of the Number Code, I came face to face with the obvious fact: a consistent pattern of numbers, all telling the same story, could only have been encoded into the text by a higher power than that of the human writers.

Then, after becoming acquainted with the concept of an Equidistant Letter Sequence code, I pondered the magnificent implications of the existence of both codes. What if the codes were combined, forming a third code: the ELS with numeric value. It had never been tried. Or at least, if it had, I certainly was not aware of it. But how could I find out? It would require the necessary software, and that software did not exist.

In my youth, I learned an old addage from an employer. He used to tell me, "When in doubt, do it the hard way." So I decided to try the ELS gematria the hard way. I had no choice. But where do I start? How do I do it? What would be the most obvious text with which to experiment?

It had appeared, over the years of working with gematria, that the name Lord Jesus Christ had taken the prominent place in the number patterns. So, I thought, what Old Testament text would be the perfect place for such a code to exist, if it did indeed exist?

Immediately the scripture came to mind that we quote every Christmas. It is found in Isaiah 9:6: **"For unto us a child is born, unto us a son is given, and the government shall be on his shoulder; and his name shall be called Wonderful, Counselor, the Mighty God, the Everlasting Father, the Prince of Peace."**

Quickly I reached for my Hebrew text and turned

to the passage. With calculator in hand, I decided to try a skip-7 sequence and add the number equivalents of every seventh Hebrew letter. When I finished the verse, I looked at the answer on my calculator, and the tingles started creeping up the back of my neck. The total was 888. It was the number of Jesus as it is spelled in the Greek New Testament. Here in the very text that is prophesying of His birth and His kingship, was encoded, by the use of the ELS Code and the Number Code, the name of Jesus!

I was ecstatic! The tears were rolling down my face! Only God could have intricately interwoven these two codes into such a short text and have it identify the very One of whom the plain text is prophesying.

But as reality began to set in, I realized that it could also be a coincidence. After all, it was only the first one I had tried. What were the evidences that it might ever happen again?

With my Hebrew text open to the book of Isaiah, I began to turn pages, scanning each page for likely examples to try. Soon my eyes fell on Isaiah 11:1. Ah, here's a good one to try. It reads: **"A shoot will come up from the stump of Jesse; from his roots a Branch will bear fruit. The spirit of the Lord will rest on him – the spirit of wisdom and of understanding, the spirit of counsel and of power, the spirit of knowledge and of the fear of the Lord – and he will delight in the fear of the Lord."**

Quickly I began counting off every seventh letter and adding it on my calculator. At the end of the text I looked at the answer. It was 888 again. With tears stream-

ing down my face I began running all through the house crying, "It's real, it's real!"

Yes, it is indeed real. Both prophecies are talking about Jesus, the babe born in Bethlehem, of the lineage of David, possessing great power and wisdom, and the spirit of the Lord, the One who will be ruler on David's throne, the One called Prince of Peace, the One who will bear the responsibility of the government of that kingdom, the One whose kingdom will last forever. He is the One! And His name, Jesus, was encoded into the text, clearly identifying Him as the one who would come, the One who would fulfill the prophecies.

When He came as the obscure baby, born in a stable, many of Israel did not believe that He was the Messiah. They saw in these prophecies a great Personage, a mighty One, a powerful One – they had hoped that this Messiah would free them from the yoke of Rome, and set up His everlasting kingdom in Israel. They failed to detect the time element in the prophecies. First, **"a child is born."** It would not be for another 2000 years before He would take the authority of rulership on David's throne. The "gap" was not specifically stated in these prophecies. We can see clearly from history that the "gap" exists. Hindsight is 20-20.

On the opposite page I show these two prophecies as they appear in the Masoretic Text. I have counted off every seventh letter and assigned its number value, then added the totals. For each of these texts, the total is 888, showing that Jesus is the One to whom the prophecy is pointing. (Remember, Hebrew reads from right to left.)

Isaiah 9:6

כי ילד ילד לנו בן נתן לנו ותהי
400 50 30

המשרה על שכמו ויקרא שמו
6 6 5

פלא יועץ אל גבור אבי עד
1 90

שר שלום
300

30 + 50 + 400 + 5 + 6 + 6 + 90 + 1 + 300 = 888

Jesus = 888

Isaiah 11:1

ותיא חטר מגוע ישי ונצר משרשיו
200 10 200

יפרה ונחה עליו רוח יהוה רוח
6 10 5

חכמה ובינה רוה עצה וגבורה
3 200 40

רוח דעת ויראת יהוה והריחו
5 1 8

ביראת יהוה
200

200 + 10 + 200 + 5 + 10 + 6 +
40 + 200 + 3 + 8 + 1 + 5 + 200 = 888

Jesus = 888

Since the number 8 is the number of a New Beginning in Jesus Christ, I wondered what a skip-8 ELS would produce.

His name can be found in several skip-8 sequences, but I want to mention only two. These two are outstanding in identifying the One who will be the New Beginner, both at the beginning of the great seventh day, and at the beginning of the great eighth day. Both of these prophecies depict the work of Jesus throughout the Millennium.

The first one is found in the prophecy of Daniel. He said: **"In my vision at night I looked, and there before me was one like a Son of Man, coming with the clouds of heaven. He approached the Ancient of Days and was led into his presence. He was given authority, glory and sovereign power; all peoples, nations and men of every language worshiped him. His dominion is an everlasting dominion that will not pass away, and his kingdom is one that will never be destroyed,"** (Daniel 7:13, 14 NIV).

Encoded into this text, by a skip-8 sequence, is the name ישׁוע, *Jesus*, clearly identifying this **"One like a Son of Man."** He receives the authority of the kingdom, its sovereign power, and during His administration, all peoples, nations, and men of every language will come to know and worship Him. And when the Millennium is complete, and the great eighth day begins, that government which He established will never pass away.

The prophet Isaiah described that wonderful time. He said, **"A highway will be there; it will be called the**

Way of Holiness ... only the redeemed will walk there, and the ransomed of the Lord will return. They will enter Zion with singing; everlasting joy will crown their heads. Gladness and joy will overtake them, and sorrow and sighing will flee away, " (Isaiah 35:8-10). What a beautiful prophecy! And encoded into it, by a skip-8 sequence is the name ישׁוע, *Jesus*. He told his disciples **"I am the Way, the Truth and the Life."** He is the Way of Holiness. All who walk in that Way will receive life in abundance of joy. He is their New Beginning.

The skip-8 ELS is exciting because it tells of the New Beginning in Jesus Christ. But the number 9 also has great significance in the coding of the scriptures. The number 9 is the last of the digits, therefore it represents completion. But this is more than the perfection of the number 7. The Greeks called it the Ennead, and they said it was the principle of completion and accomplishment. It can be seen in the fact that the numbers in the dimensions of the earth, sun and moon each have a digital root of 9. The name Lord Jesus Christ, whether we spell it in Greek or Hebrew, has a digital root of 9. Its meaning of completeness appears to go beyond the concept of the number 7, and into the concept of ultimate manifestation. It describes God's realm. The number in scripture that always represents God's realm, 144, has a digital root of 9. The two concepts and inseparable.

The triplet of nines can be found in the very first verse of the Bible. **"In the beginning God"** has a numeric value of 999. When Jesus said **"I am the root and the offspring of David,"** He was saying, I am part

of God's realm, for **"I am the root,"** has a numeric value of 999. Ultimately, by the end of the Millennium and the beginning of the great 8th day, all mankind will be in God's realm. Then will be the ultimate **"Glory to God,"** which has a numeric value of 999.

Realizing the importance of the number 9 in the ultimate completion of the plan of God for the salvation and restoration of man, I wondered what a skip-9 ELS of the name Jesus would produce.

The results of the search are magnificent! I will only make mention of a few of them. The last text that we observed using a skip-8 sequence was the beautiful promise in Isaiah 35:8-10 where God has promised that He will make a Way for all to return to Zion. That "Way" was Jesus. And we saw His name encoded into the text. A similar word picture is given to us by Jeremiah. He said, **"In those days, at that time, declares the Lord, the people of Israel and the people of Judah together will go in tears to seek the Lord their God. They will ask the way to Zion and turn their faces toward it. They will come and bind themselves to the Lord in an ever-lasting covenant that will not be forgotten, "** (Jeremiah 50:4 & 5). Encoded within this beautiful prophecy is the name ישוע, *Jesus*, by a skip-9 ELS. Truly He is "The Way."

In the skip-7 sequence we saw evidence that Jesus was represented by the red heifer, and that the cleansing that was pictured would be during the great seventh day – earth's great Millennium. In those same verses where we found the name of Jesus by a skip-7 sequence, we also find Him by a skip-9 sequence. It reads, **"The man**

who is clean is to sprinkle the unclean person on the third and seventh days, and on the seventh day he is to purify him. The person being cleansed must wash his clothes and bathe with water, and that evening he will be clean," (Numbers 19:19). Within this text, by a skip-9 sequence is the name ישוע, *Jesus*.

Notice that on the seventh day, the man being cleansed will indeed be clean at evening. It pictures the cleansing of mankind during the whole of the Millennium, and at the end they will be clean – ready to begin the great 8th day.

Similar language is used in Zechariah 14: "**It will be a unique day ... a day known to the Lord ... when evening comes there will be light ... the Lord will be king over the whole earth. On that day there will be one Lord, and his name the only name,**" (Zechariah 14:6-9 NIV). The light that prevails at evening time corresponds to the fact of the cleansing from sin being complete at evening. It will be the time of ultimate completeness, as is represented by the number 9.

There is another beautiful picture of this day of cleansing and bringing of light. It is a day of freedom from the death penalty incurred by Adam. By the end of that Millennium, the death penalty will have been completely eradicated and its effects healed. This is pictured by the Cities of Refuge that God instructed the Israelites to build. These cities were for the express purpose of providing a safe haven for anyone who had committed involuntary manslaughter, picturing the condition of all mankind because of the sin of Adam. If such a person

would flee to one of the Cities of Refuge, he would be safe from the avenger.

Each of these six Cities of Refuge was to be built according to the specific instructions that God gave to them. Each city was to be a square which was surrounded by a larger square area set aside for pasture and gardens. The perimeter of the whole area is given in the Bible as 16,000 cubits. The cubit in use at that time was the old Sumerian cubit of 19.8 inches. Thus by conversion to our British measures, the perimeter of the suburbs of the city would be 316,800 inches – each side being 79,200 inches.

```
┌─────────────────┐
│                 │
│                 │
│                 │
│  City of Refuge │
│ including its suburbs. │
│                 │
│                 │
│                 │
└─────────────────┘
```

79,200 inches, each side
316,800 inches, perimeter

7,920 miles, each side
31,680 miles perimeter

The meaning becomes obvious. The Cities of Refuge represent mankind's refuge in Jesus – refuge from the penalty incurred by the sin of Adam. The place of refuge is the earth. And just as the perimeter of each of these cities bore the number 3168 and 7920, the numbers for Lord Jesus Christ both in Greek and in Hebrew (as was shown on page 14), it also represents the *place of salvation* – the earth, whose diameter is 7920 miles. And, as we observed on page 15, the word *salvation*, in the Hebrew text, has a numeric value of 792.

So, it is exciting to find within the instructions by God to make these six Cities of Refuge, the name of ישרע, *Jesus*, by a skip-9 sequence. The text reads, **"These six towns will be a place of refuge for Israelites, aliens and any other people living among them, so that anyone who has killed another accidentally can flee there,"** (Numbers 35:15 NIV).

Isaiah prophesied of the time when this work of salvation would be complete, and the beginning of the great 8th day would be a glorious reality for man. He said:

"...you will call your walls Salvation and your gates Praise. The sun will no more be your light by day, nor will the brightness of the moon shine on you, for the Lord will be your everlasting light, and your God will be your glory. Your sun will never set again, and your moon will wane no more; the Lord will be your everlasting light and your days of sorrow will end. Then will all your people be righteous and they will possess the land forever. They are the shoot that I have planted, the work of my hands, for the display of my

splendor. The least of you will become a thousand, the smallest a mighty nation. I am the Lord; in its time I will do this swiftly," (Isaiah 60:18-22 NIV).

Encoded within this beautiful prophecy, by a skip-9 sequence, is the name ישוע, *Jesus.* It is through His offering of Himself at Calvary that all mankind will have this opportunity for life. And it is through the administration of His righteous kingdom during earth's great Millennium that man can be brought to the kind of perfection and oneness with God that Isaiah so beautifully described.

Isaiah was prophesying the same event that the Apostle John saw in vision, which he described as the **"New Heaven and New Earth."** John described the conditions of this New Heaven and New Earth, and among many other beautiful things he said, **"The city does not need the sun or the moon to shine on it, for the glory of God gives it light, and the Lamb is its lamp. The nations will walk by its light, and the kings of the earth will bring their splendor into it. On no day will its gates ever be shut, for there will be no night there. The glory and honor of the nations will be brought into it,"** (Revelation 21:23-25 NIV). One would suspect that both John and Isaiah had seen the same vision, for they described it nearly identically.

God gave to Isaiah another description of this New Heaven and New Earth, which begins earth's great 8th day. He said **"Behold, I will create new heavens and a new earth. The former things will not be remembered nor come into mind. Be glad and rejoice forever in what**

I will create, for I will create Jerusalem to be a delight and its people a joy. I will rejoice over Jerusalem and take delight in my people; the sound of weeping and of crying will be heard in it no more," (Isaiah 65:17-19 NIV). Within the text of this magnificent promise, by a skip-9 sequence, is the name יהושע, *Jesus.* Yes, the number nine is truly the ultimate completeness, for it ushers in eternity.

I have only shown a few of the magnificent uses of the ELS Code in the Masoretic Text of the Old Testament. From these it is easily discernable that the ELS Code was put there by a Masterful Intelligence, just as was the Number Code. And both tell the same story. They tell the story of Jesus, the story of redemption, the story of restoration of all that Adam lost, the story of complete reconciliation to God in an eternity of the beauty of life. This is the real and important message of the Codes.

Thus far we have seen that the Symbol Code, the Number Code and the ELS Code all tell the same story. Each confirms the other. And although the Bible has come down to us from the writings of many authors, over a period of several millennia, the codes reveal that it is from one Divine Author, for it is beyond the scope of man's ability. The codes also are in complete harmony with the plain text, and often reveal the time, place, and personages mentioned in the plain text.

Do the codes reveal a date-line or schedule of events? It may be! A time-line can be obtained from the plain text, bringing us up to the present day, and we have prophecies that indicate events in the future. By induc-

tive reasoning, and often by deductive reasoning, we are able to project the time-line into the future, in harmony with the plain statements of scripture. The same method is possible using the message in the codes. Apparent dates are indicated, and when taken in light of the plain text in which they are found, they become exciting guide-posts. But I'm getting ahead of the story again. Before examining a time-line, let's look at another of the magnificent codes that has been given to us, for the aid of understanding the plan of God for the salvation of man through Jesus Christ.

4
The Constellation Code

"The heavens declare the glory of God; the skies proclaim the work of his hands. Day after day they pour forth speech; night after night they display knowledge. There is no speech or language where their voice is not heard. Their voice goes out into all the earth, their words to the ends of the world," (Psalm 19:1-4 NIV).

How do the heavens speak? We look up into the night sky, and although we see a marvelous array of starry splendor, we do not *hear* a sound. Yet we are told that their voice and their words go to the ends of the world. If we hear nothing, then they must be communicating in some code that does not require sound. And if so, what are they saying?

Using the Number Code we can get our first clue as to what the heavens are telling us.

888 = The heavens declare the glory of God

השמים מספרים כבוד אל

888 = Jesus, *Ιησους*

The heavens do indeed tell the story of redemption through Jesus. It is His story, and it is emblazoned across the sky every night. It is written there in a pictorial code – the Constellation Code.

In Genesis 1:14 we read, **"God said Let there be**

lights in the expanse of the sky to separate day from night, and let them serve as *signs* to mark seasons and days and years," (NIV).

This translation is somewhat misleading. The literal word for word translation from the Hebrew text reads: "...let them be for signs, and for seasons, and for days and for years." The *signs* were not put there to mark the seasons. The *signs* were a separate function in addition to the seasons, days and years. They were to tell us something beyond and additional to their function as forming our yearly clock. It is evident that from the beginning, the Creator intended these orbs of light to convey some special message, beyond their yearly function. They were to be for signs – for a witness. Signs and witness of what?

The function of the constellations as a witness is evident from the Number Code. In the Greek text of the New Testament, the words "constellation" and "witness" bear the same number.

1071 = Constellation, αστρου
1071 = Witness, μαρτυριον

God encoded into the Psalm of David the message of the signs. It is the story of Jesus – 888.

A sign is something arbitrarily selected to represent some other thing. For instance, the letters of our alphabet are *signs* of sounds and numbers. Music is written with a set of *signs* that tell us tones, pitch and rhythm. And likewise the stars are a magnificent set of signs that

tell the whole story of redemption through Jesus.

At the time of the birth of Jesus, the Bible tells us
that men from the east knew of His birth by astronomi-
cal signs. We are not told how they deduced this from
the stars. We only know that they deciphered the code,
believed its message, and traveled far across the desert
to visit the new king who had been born.

The constellations, as they have come down to us
from the most ancient of times, are replete with serpents,
warriors, animals, and, yes, even the cross. Likewise the
whole story of the redemption of man as found in the
Bible is the conflict between the serpent (Satan) and the
heavenly warrior, the Lion of Judah – the serpent and
the Messiah – and the pivotal point in the conflict is the
cross. In the Number Code they both bear the same num-
ber.

358 = Serpent, נחש
358 = Messiah, משיח

This sameness of the numbers is not unique, it is
not a lone occurrence. The conflict between the Serpent
and Messiah is shown by the Number Code throughout
the Bible, both Old and New Testaments. Let me digress,
for a moment, and bring some of these to our attention.
Then as we proceed through the starry code, the reality
of this conflict will be more firmly developed in our
awareness.

The prophet Isaiah told of Satan's usurpation of
God's throne. **"I will ascend to the heaven; I will raise**

my throne above the stars of God; I will sit enthroned on the mount of the assembly, on the utmost heights of the sacred mountain. I will ascend above the tops of the clouds; I will make myself like the Most High," (Isaiah 14:13-14 NIV).

364 = Anointed One (the Messiah), מָשִׁיחוֹ, (Psalm 2:2)
364 = Satan, הַשָּׂטָן

Here we have the same as is shown above with Messiah and the Serpent. They are not random numbers. They show the ambition of Satan to usurp the position of ruler.

1850 = The Messiah, Word of the Father,
 ο Μεσσιας Λογος Πατρος
1850 = The strongman, τον ισχυρον

Jesus called Satan the "strongman" in Matthew 12:29. He was telling the Pharisees that He must first bind the strongman before He could take the strongman's possessions. The strongman's possessions are the kingdoms of this world. Revelation 11:15 speaks of the time when this happens: **"The seventh angel sounded his trumpet, and there were loud voices in heaven, which said, The kingdom of the world has become the kingdom of our Lord and of His Christ,"** (NIV). He not only entered the strongman's house, He also took all his possessions.

The usurper of this position is shown again by the

number 75.

75 = The Son, ο υιος
75 = Lucifer, הילל, (Isaiah 14:12)

Of course, we are not to leave out the most well-known number of them all – 666. For nearly 2000 years men have attempted to identify Mr. 666. We know him in Revelation 13:18 as the "Beast." We are instructed, **"If anyone has insight, let him calculate the number of the beast, for it is man's number. His number is 666,"** (NIV).

Just as all his other numbers, it is the number of an imposter. For this number elsewhere in the Number Code is obviously a number of supreme deity.

666 = Jehovah God that created the heavens,
 האל יהוה בורא השמים, (Isaiah 42:5)
666 = Your great and fearful name,
 שמך גדול ונורא, (Psalm 99:3)
666 = Head of the corner (Jesus applied this title to
 Himself in Matthew 21:42)
 לראש פנה, (Psalm 118:22)

The statement in Revelation 13:18 regarding the number of the beast has a hidden number that was encoded into the text. It reveals Mr. 666 as being the imposter of Jesus Christ.

2368 = Jesus Christ, Ιησους Χριστος
2368 = And his number is six hundred and sixty six,
 και ο αριθμοσ αυτου Χξς', (Revelation 13:18)

(This is the only place in the entire New Testament where the Greek symbol for 6 is used. This letter, called *"stigma"* was dropped from the Greek alphabet, and was thenceforth only used to represent a number.)

Thus the serpent and the warrior become the dominant characters in the story written in the starry heavens. The warrior is sometimes portrayed as a shepherd, and sometimes as a king – but the theme that is intricately interwoven into these celestial pictures is the slaying of the serpent by the conquering Hero.

But, we might ask, where did they get those pictures of serpents, warriors and kings? If we were to "connect the dots," from star to star we certainly would not find all those elaborate and descriptive pictures. In fact, most of the star positions in the constellations have no apparent relation to the pictures drawn around them. Yet these very pictures form the ground work of all celestial maps, both in ancient and modern times, and from the remotest parts of the world. They are part of a common and universal language of astronomical science.

It has been suggested[1] that the plan of God for the redemption of man was given to Adam. After all, it was his own redemption that was necessary in order to purchase the human race, yet in his loins, from the death penalty.

We know that these signs have been found in the earliest records of man. The book of Job in the Old Testa-

1 Joseph A. Seiss, *The Gospel in the Stars*, first published in 1882, later published by Kregel, Inc., Grand Rapids, MI in 1972, page 150.

ment is said to be one of the oldest books in the Bible, and it makes mention of the Zodiac, Orion, the Pleiades and other celestial signs.

The great antiquity of these signs precedes the original writing of any of the known books which make up our Bible, or, for that matter, any known writing whose copies are extant today. By counting the cycles backward it has been deduced that astronomy had its beginning when the summer solstice was in the first degree of Virgo, which places it *before* the great Biblical flood.

The historian, Josephus, who lived in the first century A.D., said that the plan of the heavens was recorded by Adam and his son Seth. "They also were the inventors of that peculiar sort of wisdom which is concerned with the heavenly bodies, and their order," (*Ant.* Book I, Chapter II).

In fact, it has been observed that when the Zodiac, Planets, Sun and Moon are calibrated with the ancient Hebrew alphabet, an exact notation of the positions of the heavenly bodies, as they would have been observed in 3447 B.C. can be obtained.[1] This would place it during the lifetime of Adam and Seth.

If God has indeed encoded the heavens, how are we to decipher the code? First, let's look at the pictures as they appear in the order in which they have come down to us from ancient times.

The twelve signs that are connected to the apparent path of the sun are called the Zodiac. The path of the

1 *Ibid*, page 23

sun, called the ecliptic, passes through each of these twelve signs during the course of one year. However, during its yearly course, it slips back slightly along the ecliptic, so that in 25,920 years it has slipped back the entire circuit. This is called the Great Year. The sun, at a given point of time in each year, is in each of the twelve signs for a period of 2160 years.

The ancient Sphinx, guardian of the pyramids of Giza, has the head of a woman, and the body of a lion. It is a representation of the Great Year of 25,920 years, beginning with the head of the woman, Virgo, and ending with the lion, Leo. Thus it confirms the ancient order of the Zodiac.

Each of these twelve signs has three accompanying constellations, called Decans; thus making four constellations in each division of the Zodiac. There are twelve divisions in all, consisting of 48 signs.

1. Virgo
> Coma
> Centaurus
> Boötes

2. Libra
> The Cross
> Victim of Centaur
> The Northern Crown

3. Scorpio
> The Serpent
> Ophiuchus
> Hercules

4. **Sagittarius**
 Lyra
 Ara
 Draco
5. **Capricornus**
 Sagitta
 Aquila
 Delphinus
6. **Aquarius**
 The Southern Fish
 Pegasus
 Cygnus
7. **Pisces**
 The Band
 Cepheus
 Andromeda
8. **Aries**
 Cassiopeia
 Cetus
 Perseus
9. **Taurus**
 Orion
 Eridanus
 Auriga
10. **Gemini**
 Lepus
 Canis Major
 Canis Minor

11. **Cancer**
 Ursa Minor
 Ursa Major
 Argo
12. **Leo**
 Hydra
 Crater
 Corvus

The evidence from the Bible is that God, Himself, gave these constellations their names, as well as their numbers. **"Lift up your eyes and look to the heavens: who created all these? He who brings out the starry host** (constellations) **one by one** (or, by number), **and calls them each by name. Because of His great power and mighty strength not one of them is missing,"** (Isaiah 40:26 NIV). **"He determines the number of the stars and calls them each by name,"** (Psalm 147:4).

The Constellation Code tells the story of redemption through Jesus Christ. Let's begin where the story begins – with the first constellation of the Zodiac, Virgo.

Book I, Chapter 1

The constellation of Virgo, with its three accompanying Decans is sort of an overview of the whole conflict and victory of the Promised Seed. The message is specifically the coming of Jesus – His coming as the babe of Bethlehem; as the offering for sin; and as the victor over evil.

Virgo is the picture of a woman, who, in relation to

the path of the ecliptic, appears to be prostrate, on her back. She holds in her right hand a sheaf of ripe grain (seed grain).

The name of this sign in Hebrew means *a virgin.* In Arabic it means *a branch.* In Latin the two descriptions are brought together in the words *virgo,* virgin, and *virga,* which means branch. The idea is that the branch is the offspring of the virgin. Surely whoever named this constellation knew that such a thing is not only contrary to nature, but from a human standpoint is biologically impossible.

Yet Isaiah was led to prophesy, **"Therefore the Lord Himself shall give you a sign, Behold the virgin shall be with child and shall bring forth a son; and she shall call His name Immanuel,"** (Isaiah 7:14 KJV II).

The fulfillment of the prophecy is found recorded in the book of Matthew. **"This is how the birth of Jesus Christ came about: His mother, Mary, was pledged to be married to Joseph, but before they came together, she was found to be with child through the Holy Spirit. Because Joseph, her husband, was a righteous man and did not want to expose her to public disgrace, he had in mind to divorce her quietly. But after he had considered this, an angel of the Lord appeared to him in a dream and said, 'Joseph, son of David, do not be afraid to take Mary home as your wife, because what is conceived in her is from the Holy Spirit. She will give birth to a son, and you are to give him the name Jesus, because he will save his people from their sins.' All this took place to fulfill what the Lord had said through**

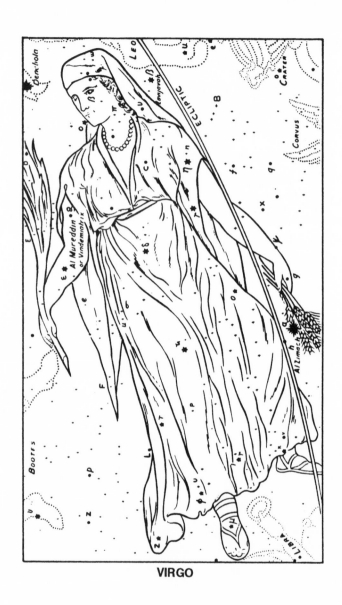

VIRGO

the prophet, 'The virgin will be with child and will give birth to a son, and they will call him Immanuel – which means, God with us,' " (Matthew 1:18 - 22 NIV).

All of this came as the fulfillment of a previous prophecy, given in the Garden of Eden. After the serpent had deceived Eve, and it resulted in Adam disobeying God's command, God placed a death sentence upon the serpent. He said, **"On your belly you shall go, and you shall eat dust all the days of your life. And I will put enmity between you and the woman, and between your seed and her seed. He will bruise your head, and you shall bruise his heel."**

Thus in the star-signs we have been given this first picture in the Zodiac – that of a virgin with seed in her left hand and a branch in her right hand.

In the sheaf of grain in her left hand is the bright star Spica, meaning *an ear of grain.* Its ancient Arabic name is *Al Zimach,* which means *the branch.* The bright star in her right arm (in which she holds a branch) is *Al Mureddin,* which means *who shall come down,* or *who shall have dominion.* It is also known as *Vindemiatrix,* a Chaldee word meaning *the son, or branch who comes.* The bright star in the virgin's hair is *Zavijaveh,* meaning *the gloriously beautiful.* The gloriously beautiful branch was spoken of by the prophet Isaiah: **"In that day will the Branch of Jehovah be beautiful and glorious,"** (Isaiah 4:2).

In the Old Testament there are 12 different Hebrew words translated by the English word "branch." One of them is used exclusively as prophetic of Jesus. This word is צמח, *tsemach,* which has a number value of 138. His

identification becomes apparent.

138 = The Branch, צמח
1380 = The Man (Jesus), ο ανθρωπος, (John 19:5)

This gloriously beautiful Branch bears some exciting numbers in the Number Code.

3368 = In that day will the Branch of Jehovah be
 beautiful and glorious, and the fruit of the
 earth for pride and for glory for the survivors
 of Israel, (Isaiah 4:2)
3368 = Lord Jesus Christ, Κυριου Ιησους Χριστος

The description of beautiful and glorious adds to 200. Without this description the text adds to 3168, which is the number for Lord Jesus Christ when Lord is spelled Κυριος. Thus we have:

$$
\begin{array}{rl}
3168 & = \text{Lord Jesus Christ} \\
\underline{+200} & = \text{beautiful and glorious} \\
3368 &
\end{array}
$$

Also, encoded within this text is another number which identifies the Branch with Jesus.

432 = The Branch of Jehovah, beautiful and glorious.
 (This description both *adds* and *multiplies* to 432.)
432 = The Saviour, מושיער

Again, within this same text, is further evidence pointing to Jesus as the Branch:

$$
\begin{aligned}
296 &= \text{The Branch of Jehovah beautiful} \\
296 &= \text{and the fruit} \\
+\ \underline{296} &= \text{of the earth} \\
888 &= \text{Jesus}
\end{aligned}
$$

Such an intricate encoding of the written word and the starry heavens can only be the work of a Supreme Intelligence. And, as if to confirm the message, in case we missed it the first time, He gives it to us again – this time by the prophet Zechariah.

2368 = The Man whose name is the Branch, He shall grow up out of His place, and He shall build the temple of Jehovah, (Zechariah 6:12).

2368 = Jesus Christ, *Ιησους Χριστος*

The First Decan of Virgo

This constellation was named Coma, which means *The Desired One*, or *The Desire of Nations*. It depicts a virgin holding a small boy on her lap. An 8th century Arabian astronomer, who, by the way, was not a believer in Jesus, however, when describing the constellation Coma, called it "a young woman whose Persian name denotes a pure virgin, sitting on a throne, nourishing an infant boy, having a Hebrew name ... *Ihesu*." Anyone who knows Hebrew is aware that this is the name Yeshua, whose Greek form is Jesus in the New Testament.

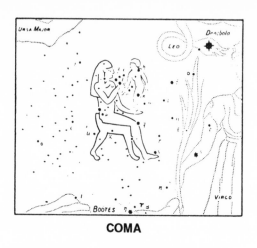

COMA

The ancient Egyptian name for this constellation is *Shes-nu, the desired son.* It is also known as *The Desire of Nations.*

The promised Messiah was known to ancient Israel as *The Desire of Nations,* and often as *The Desire of Women.* It was the ultimate hope and wish of every Hebrew woman to give birth to the promised Messiah – thus the idea came to be called *The Desire of Women.*

The prophet Haggai speaks of a future time when The Desire of Nations will indeed come. **"For thus says Jehovah of hosts, 'Yet once, it is a little while, and I will shake the heavens and the earth and the sea and the dry land. And I will shake all nations; and the desire of all nations shall come.'"** (Haggai 2:6-7 KJV II)

The time setting for the fulfilling of this prophecy is the return of the Messiah, when He brings peace to the nations. **" 'And in this place I will give peace,' says Jehovah of hosts,"** (V. 9). The coming of The Desire of Nations, in the Number Code, bears the number 528.

What a fantastic number! Here are some of its uses in scripture.

528 = And shall come the Desire of Nations,
ובאו המדת הגוים, (Haggai 2:7)

528 = The day of His coming,
ומי את-יום בואו, (Malachi 3:2)

528 = The breaking forth of light, כשחר, (Hosea 6:3)

528 = The key, מפתח, (Isaiah 22:22) (When Messiah returns He will have "the key" of the house of David, for He will come as King Messiah and rule on David's throne.)

It is exciting to realize that if we add these four occurrences of the number 528, which refer to His coming, the total would be 2112.

2112 = A virgin shall conceive and bear a son and shall call His name Immanuel, (Isaiah 7:14)

This is the story of Coma. She sits in the starry heavens every night, holding the precious and beloved boy on her lap. Shakespeare called him "The good boy in Virgo's lap."[1]

The Second Decan of Virgo
Centaurus depicts a creature that is part man and part horse. Its name in both Arabic and Hebrew means

1 *Titus Andronicus*, Act IV, Scene 3

the despised one. The Greeks called him Cheiron, which means *pierced*. These two names describe the work of Jesus as a sin-offering.

"He is despised and abandoned of men, a man of pains and acquainted with sickness. And as hiding of faces from Him, being despised and we did not value Him," (Isaiah 53:3, KJV II)

"They pierced My hands and My feet," (Psalm 22:16).

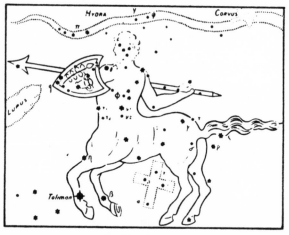

CENTAURUS

The Centaur is fully man from the head to his feet, however, his back parts become the body and back legs of a horse. It depicts a dual nature. Jesus was a perfect man. The scriptures tell us that He was **"whole, harmeless and separate from sinners."** Yet we are told in Romans 8:3 **"...God, sending His own Son in the like-**

ness of sinful flesh, and for sin, condemned sin in the flesh."

Even though He was a perfect man, yet He took the sinner's place. And because He represented the sinner, it was necessary for His Father to turn His face from Him as He hung on the cross. Feeling the abandonment of the Father's favor, He cried out in anguish, **"My God, My God, why hast thou forsaken me?"** At that moment in time, His perfect manhood took upon Himself the sin of Adam. The perfect Man was now represented by a creature of less than perfect human nature – something that had degraded to animal nature. This supreme sacrifice He did for us! And it was at this moment, as He cried out in anguish to His Father, that He is represented in the heavens by the figure of a Centaur. Beneath His body, between the front legs and the back legs, is the constellation of The Cross.

The Third Decan of Virgo

Here we see a great and strong shepherd, as if running, carrying in one hand a spear to ward off the enemies of the flock, and in his other hand he holds high a sickle with which to reap. These are not the ordinary tools of a shepherd. He has been named Boötes, *the Coming One.*

The chief star in this constellation is Arcturas, *the guardian of the sheepfold.* The bright star on his right arm is *Al Katurops*, which means *the branch.* The bright star in his head is *Nekkar*, which means, *the pierced one.*

In Boötes we have a composite picture of Jesus as

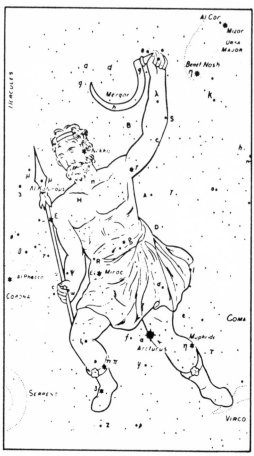

BOÖTES

The Branch who came up from the "root of Jesse" (the line of David), and, because He gave His life for the sheep, He becomes the guardian of the flock, gently leading them into the sheepfold (represented by the constellations of Ursa Minor, Ursa Major, and Argo, which are nearby), and holding a sickle in His hand with which to reap a harvest.

This is in complete harmony with the same story

told in the Number Code.

280 = Shepherd, רעי, (Psalm 23:1)
280 = His flock, עדרו, (Isaiah 40:11)
28 = Sin-offering, חטיא,
280 = Bullock, פר, (The animal used as a sin-offering in the Tabernacle.)
280 = Exalted (lifted up), רמם, (After giving His life for His sheep, He was highly exalted by the Father.)

256 = Shepherd, ποιμενα
 1480 = Christ, Χριστος
 + 1080 = The Holy Spirit, το αγιον πνευμα
 2560
256 = Holiness, αγιασμα
256 = Truth, αληθης
256 = He shall be exalted, ירום, (Isaiah 52:13)

Jesus referred to Himself as the Good Shepherd. He said, **"I am the Good Shepherd ... and I lay down my life for the sheep,"** (John 10:14). And the writer of the book of Hebrews climaxes the concept with, **"The God of peace, who through the blood of the eternal covenant, brought back from the dead our Lord Jesus, that great Shepherd of the Sheep ..."** (Hebrews 13:20).

Summary of Virgo
Virgo and her three accompanying Decans make up the first chapter in the first book of the Constellation

Code, written in the starry heavens. They tell, in brief, the whole story of the coming of Jesus as man's redeemer and sin-offering, of His exaltation, and His gathering of all into the sheepfold. The Apostle Paul summed it up succinctly when he said, **"...that in the dispensation of the fulness of times He might gather together in one all things in Christ, both which are in heaven, and which are on earth; even in Him,"** (Ephesians 1:10).

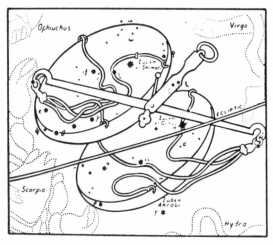

LIBRA

Book I, Chapter 2 – Libra

Libra is the second sign of the Zodiac. It is pictured by a set of scales for weighing. Its three Decans are The Southern Cross, The Victim, and The Northern Crown. This chapter in the Constellation Code tells the story of redemption.

Libra is a Latin word meaning *weighing*. It is pictured by a pair of balances. The only way for both sides of balance scales to be even, or equal in position, is to

place equal weights on each side. This is exactly what is meant by the Greek word for "ransom," *anti-lutron,* a *redemption price.*

The Apostle Paul identified the One who was our Redemption Price. **"For there is one God, and one Mediator between God and men, the man Christ Jesus, who gave himself a ransom (anti-lutron) for all, to be testified in due time,"** (I Timothy 2:6).

There is no question about the identity. Paul spelled it out plainly. But the Number Code further proves the identification.

3168 = Mediator between God and men,
 μεσιτησ Θεου και ανθρωπων
3168 = Lord Jesus Christ, Κυριος Ιησους Χριστος
3168 = The Son of Man, η υιου του ανθρωπου

The Hebrew word for scales is מאזנים, *mozanim.* In the Number Code, the addition of its number equivalents is 148. This number beautifully tells the story of man's redemption. First it tells the story of the purchase of the firstborn of the Israelites on the night that all the firstborns of Egypt died. The Israelites were instructed to kill a lamb, and sprinkle its blood around the door frames of their houses; and all the firstborns within the house would be saved from death. The transaction was the blood of a lamb in exchange for the blood of a man. The event was called the Passover. It pictured the death of Jesus, the Lamb of God, taking the place of Adam – the *anti-lutron,* the redemption price. The Apostle Paul

again identified the One when he said, **"Christ our Pass-over is sacrificed for us,"** (I Corinthians 5:7).

148 = Scales, מאזנים
148 = Blood, נצח (The price of redemption)
148 = Passover, פסח
1480 = Christ, Χριστος
1480 = Son of God, υιος Κυριος

The Chaldean word for scales is *Tekel*. This word is used in Daniel 5:27, thus we are given the Hebrew spelling, תקל, which adds to 530. The Greek spelling of "scales" in the New Testament is ζυγον, which also adds to 530. The fact that the numbers are identical further identifies the One who balanced the scales of justice by the giving of His perfect manhood, in exchange for the forfeited perfect manhood of Adam.

530 = Tekel, תקל, (Daniel 5:27)
530 = Scales, ζυγον, (Revelation 6:5)
530 = Son, υιον, (Son of Man and Son of God)
5300 = His life a ransom for many, ψυχην αυτου λυτρον αντι πολλων, (Matthew 20:28)

The bright star in the sign of Libra is *Zuben Al Genubi*, meaning *the price deficient*. It has reference to Adam. The bright star on the other side of the scales is *Zuben Al Shemali*, meaning *the price which covers*. Even these ancient names show the transaction – weighing the rewards of sin on one side, and balancing it with the price

of redemption on the other side. There is no mistaking the significance.

The First Decan of Libra

This beautiful constellation is the Southern Cross – and it actually is in the form of a cross. It is one of the few constellations whose stars actually look like its name. It can only be seen today in the southern hemisphere. Because of the gradual precession of the stars, this magnificent cross, which at one time could be seen in the northern hemisphere, slipped below our horizon about the time that Jesus lived in Jerusalem. After His death, it could no longer be seen from Jerusalem.

The sign of the cross has been a most sacred and significant emblem to all Christian believers. It was used in symbol as the last letters of the Hebrew alphabet,

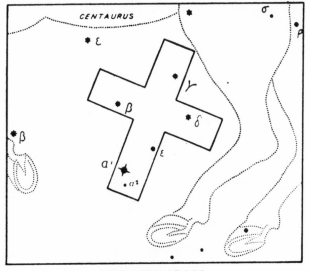

SOUTHERN CROSS

which, in ancient Hebrew was written similar to our letter T. It took its place as the *final* letter of their alphabet, *tau*, just as Jesus symbolized on the cross when he said, **"It is finished."**

The Hebrew name for this constellation is *Adom*. It carries the meaning of *cutting off*. And this is what was spoken of by the angel Gabriel when he gave Daniel the counting of the time till the cutting off of Messiah. However, the word used here for cutting off is יכרת, and it is translated "shall be cut off." Interestingly, it bears the number 630. It is one of the basic numbers in the Number Code. Its multiples tell the whole story of redemption. When Moses told the Israelites that "a prophet" would be raised up like himself, he was referring to Jesus. The Hebrew word that Moses used for "a prophet," נביא, adds to 63.

In the Egyptian Zodiac of Denderah, this fsirst Decan of Libra is pictured as a lion expressing great thirst, and beside him a woman holding out a cup to him. This lion, according to the Egyptians, is called *Sera*, which means *victory*. Thus the Lion of the tribe of Judah, Jesus, when hanging on the cross, said, "I thirst." But He gained the victory when He said, "It is finished."

The Second Decan of Libra

This is the Victim. It is often portrayed as a wolf and thus it is given the Latin name of *Lupus*. Actually it could be any animal portrayed in the act of falling down dead.

According to the Greeks its name is *Thera, a beast*.

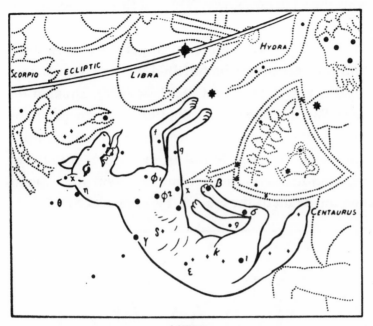

LUPUS

Its ancient Hebrew name was *Asedah*, which means *to be slain*. The interesting thing is that he is being slain by Centaur. Now if this dying animal represents Jesus' death, then how could Centaur, who represents the manhood of Jesus, be shown as killing him?

Jesus answered this when He told His disciples, **"I lay down my life, that I might take (receive) it again. No man taketh it from me, but I lay it down of myself."** He made it clear that His death was a voluntary sacrifice. And even though He was nailed to a cross by Roman soldiers, His life was freely given. For when Peter drew his sword to prevent Jesus from being arrested by the Roman soldiers, Jesus told him to put the sword

away, then He explained: **"Do you think I cannot call on my Father, and He will at once put at my disposal more than twelve legions of angels? But how then would the scriptures be fulfilled that say it must happen this way?"** (Matthew 16:53, 54 NIV). Thus, in the Constellation Code, the Victim (Jesus) is being slain by Centaur (Jesus), just as the Apostle Paul so beautifully expressed: **"...being found in fashion as a man, he humbled himself, and became obedient unto death, even the death of the cross,"** (Philippians 2:8).

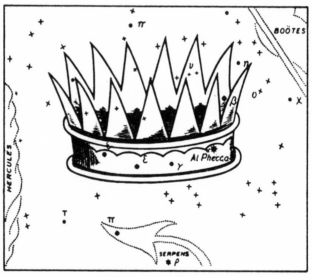

NORTHERN CROWN

The Third Decan of Libra - The Northern Crown

The soldiers who mocked Him, placed on His head a crown of thorns, but His Father in heaven has placed on Him a royal crown. The Hebrew name for this constellation is *Atarah*, עטרה, which, in the Number Code,

adds to 284. How beautiful the number. And how appropriate!

284 = Royal crown, עטרה

284 = God, Θεος

284 = Holy, αγιος

284 = In the greatness of your majesty, ברב גאונך, (Exodus 15:7)

284 = Excellence, αγαθος

Summary of Libra

This second chapter in Book I of the Constellation Code is the story of redemption – the balancing of the scales of justice – **"As in Adam all die, so in Christ shall all be made alive,"** (I Corinthians 15:22). It is the story of the suffering Redeemer, who willingly offered up His life in payment for the forfeited life of Adam. And it ends with the attainment of the glorious and shining crown.

The writer of Hebrews admonished us to look upon Him, and consider the great sacrifice that He willingly offered, that we might have life. **"Let us fix our eyes on Jesus, the author and perfector of our faith, who for the joy set before him endured the cross, scorning the shame, and sat down at the right hand of the throne of God,"** (Hebrews 12:2 NIV).

Book I, Chapter 3, Scorpio

Scorpio and its three Decans tell the story of the Redeemer's conflict with, and final victory over the enemy (Satan). The star pictures tell the story so simply

and yet so vividly that they are largely self-explanatory.

Scorpio is a huge scorpion. Its Decans depict a strong man in the struggle to subdue a writhing serpent whose mouth is in the process of reaching to devour the Northern Crown; followed by Hercules, who wears the skin of a slain lion while holding in his hand a three-headed serpent.

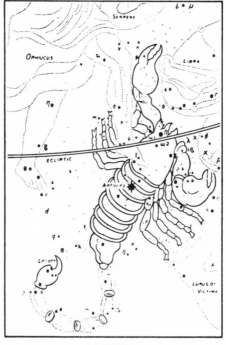

SCORPIO

Scorpio is a venomous scorpion whose lethal tail is attempting to sting the heel of Ophiucus, the strong man. Ophiucus, in turn, has his other foot on the head of the scorpion. It reminds us of the sentence God pronounced upon the serpent: **"He** (the seed of the woman) **will crush**

your head, and you will strike his heel," (Genesis 3:15).

The Number Code leaves no doubt as to the identity of the scorpion.

750 = Scorpion, σκορπιος
75 = Lucifer, הילל

The Hebrew name for Scorpio is *Akrab,* which means *the conflict.* The Arabic name is *Al Akrab, the wounding him that cometh.* Its brightest star is *Antares,* which means *the wounding.*

In the Hebrew Zodiac, the scorpion is assigned to the tribe of Dan, who was said to be **"... a serpent on the way, a horned snake on the path that bites the heels of the horse, and its rider falls backward,"** (Genesis 49:17)

Here, as in everywhere in these star pictures, the conflict is between Jesus and Satan, until evil is finally vanquished, and the Conqueror rules in righteousness.

The First Decan of Scorpio

This first Decan of Scorpio is the writhing serpent, called *Serpens.* He is reaching for the Northern Crown, which, if he were not restrained, would grasp and make his own. He is the graphic image of the event narrated by Isaiah: **"... you have said in your heart, 'I will go up to the heavens, I will raise my throne above the stars of God; and I will sit in the mount of the assembly in the sides of the north. I will rise above the heights of the clouds. I will be like the Most High,' "** (Isaiah 14:13, 14).

The brightest star in this constellation is *Unuk,* which means *encompassing.* Its Hebrew name is *Alyah,* which means *accursed.* In the Number Code it adds to 165. The name Lucifer originally meant "bright star," or "brightness." It is interesting to observe that in Hebrew the terms "brightness" and "darkness" are anagrams of each other; both of course bearing the same number. And that number is, yes, you guessed it, 165.

165 = Alyah, (accursed), קללה
165 = Brightness, יפעה
165 = Darkness, עיפה

Again we observe the usurper in the act of taking upon himself the identity of the Messiah, for the number 165 is also the number of the man, Jesus.

165 = that man (Jesus), $\alpha\nu\delta\rho\iota$, (Acts 17:31)
165 = Just One (Jesus), $\delta\iota\kappa\alpha\iota o\nu$, (Acts 22:14)

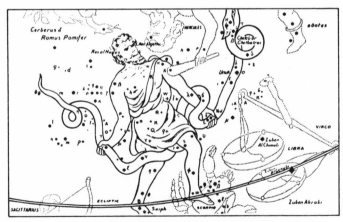

OPHIUCHUS AND SERPENS

The Second Decan of Scorpio

This Decan depicts a strong man named Ophiuchus, restraining the serpent to prevent him from seizing the Northern Crown. Ophiuchus pictures Jesus. The struggle with the serpent tells the story of contest for dominion. Satan attempted to usurp it, but Jesus obtained it as a rightful possession. The bright star which is in the head of Ophiuchus is *Ras Al Hagus*, meaning the *head of him who holds.*

The Third Decan of Scorpio

Here we have the famed Hercules. He is kneeling on one knee, with his foot held up because it had been wounded. His other foot is in the act of crushing the head of Draco, the coiled serpent. He is pictured as wearing

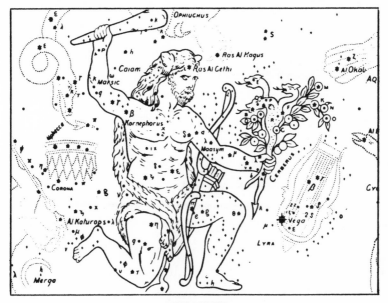

HERCULES

the skin of a slain lion, and in his left hand he holds a three headed snake; in his right hand he wields a club. He is the conqueror, who has slain the lion (Satan) and is now in complete control of the snake (Satan) with the power to crush it.

Although Jesus is spoken of in scripture as **"the Lion of the tribe of Judah,"** Satan is also pictured as a **"roaring lion, seeking whom he may devour."** Again we see Satan in the role of the usurper. This is the lion whose skin Hercules is wearing, as a symbol of conquest.

The brightest star is in the head of Hercules. It is *Ras Al Gethi, the head of him who bruises.* The next bright star is in his armpit, called *Marsic, the wounding.* The star in the left arm is *Ma'asym,* meaning *the sin offering.* While in his other arm is *Guiam, punishing or treading under foot.*

Summary of Scorpio

We see in all four of these scenes, the conflict between the strong man and the serpent – between Jesus and Satan. This story is clearly depicted in the Bible. And when Jesus was born, Satan was there to influence Herod to kill all the little boy babies in the hope of killing the baby Jesus. When Jesus came up from His baptism in the Jordan River, Satan was there to tempt Him and to offer Him **"all the kingdoms of this world"** if He would only recognize Satan as supreme.

But the Decans of Scorpio show the final outcome of the conflict. Hercules, the conquering hero, has slain the lion, and holds in his power the deadly snake. Jesus is the ultimate victor over Satan.

Book I, Chapter 4 – Sagittarius

Sagittarius is the Latin name for this constellation. It means the *Archer.* Here we have the centaur again, but this time his arrow is aimed directly at the heart of the scorpion. Thus He who took on Himself the penalty of the sin of Adam, now rides forth as the conquering warrior, destroying the great enemy, Satan. Jesus, who made Himself an **"offering for sin,"** now, in this sign of Sagittarius, appears again as triumphant over the source of sin, the scorpion, Satan.

The Hebrew name for this sign is *Keshith,* קשׁת, the Archer. Indeed, by its very number it represents Jesus.

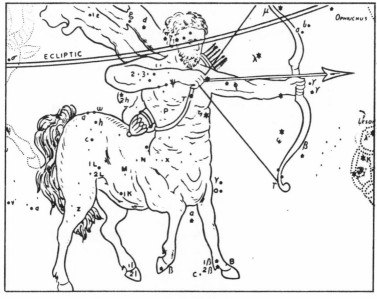

SAGITTARIUS

800 = The Archer, קשת

800 = Lord, Κυριος

800 = The Root (Jesus is the root of Jesse), שרש

8 = He who comes (Jesus), הבא

His name in Coptic is *Pimacre*, meaning *beauty of the coming forth*. The bright stars, in Hebrew, are *Naim, the gracious one;* and *Nehushta, the going forth.*

The First Decan of Sagittarius – Lyra

Lyra is a harp, but a very unusual harp. It is shaped like an eagle. In the Hebrew language, the words "harp" and "eagle" sound almost the same – *Gnasor*, harp, and *Nesher*, eagle. Such sound-alike words are often used as a "play on words." Lyra is not only an eagle, which is the enemy of the serpent, but it is an eagle ascending

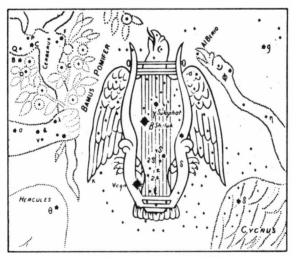

LYRA, THE EAGLE-HARP

upward in praise, thus also a harp. Here we have Jesus pictured as having conquered Satan, and now lifting up praise to Jehovah. It is a song of praise in which the whole world will join.

The illustration given to us of this eagle-harp was set to music by David in Psalm 21: **"Your hand shall find out all your enemies; your right hand shall find out those who hate you. You shall set them in a fiery furnace in the time of your presence (appearing) ... you shall make them turn back, you shall fix arrows on your string against their faces. Be exalted, O Jehovah, in your strength; we will sing, yea, sing psalms of your power,"** (KJV II).

This eagle-harp bears an interesting number in the Number Code.

576 = Eagle, αετος, (Matthew 24:28)

576 = Harp, עשור, (a decachord, or harp of ten strings) (Psalm 92:3)

This interesting number seems to be associated with these starry signs, as well as with the time of the "appearing" or "presence" of the Lord. Here is some of the evidence.

576 = Signs, מופתים, (Joel 2:30) **"And I will give *signs* in the heavens, and in the earth: blood and fire and columns of smoke. The sun shall be turned to darkness and the moon to blood, before the coming of the great and awesome**

day of Jehovah," (KJV II).

576 = The moon into blood, η $\sigma\epsilon\lambda\eta\nu\eta$ $\epsilon\iota\varsigma$ $\alpha\iota\mu\alpha$, (Acts
2:20) **"The sun shall be turned into darkness,
and** *the moon into blood,* **before that great
and notable day of the Lord come."**

576 = Trumpet, תקוע, (the blast of a trumpet)
(Ezekiel 7:14)

It appears that the message of the eagle-harp is a two-fold message. One, of the tribulation that is prophesied to accompany the return of Jesus as the promised King, and second, of the joyful song of praise that will also accompany His kingdom of peace, when He has vanquished Satan.

In the above examples of the use of 576 in the Number Code, we obtained the number by addition. But the Number Code also has the function of multiplication. Here are a few examples of the message found in the number 576 when multiplying the numeric values. (In this, as always when we multiply, the zeros are dropped.) It becomes apparent that the number 576 relates to the coming of Jesus at the time when He will take His power as King on David's throne, at the beginning of earth's great Millennium. Remember, in the examples shown below, we are *multiplying* the number values.

576 = He shall appear in His glory, נראה בכבודו,
(Psalm 102:16) (This is prophetic of the time of
His return.)

576 = Messiah the Prince, מָשִׁיחַ נָגִיד, (Daniel 9:25)

576 = Michael, Μιχαηλ, (Jude 9) (Daniel 12 speaks of the time when Michael stands up and protects his people, Israel, from the impending destruction. An end-time prophecy.)

576 = The Kingdom, מַלְכוּת, (Daniel 7:27)

576 = Anointed One (Jesus), מְשִׁיחוֹ, (Psalm 2:2) (This Psalm is prophetic of the time of Jesus' return as King. It tells of His conquering of the enemy.)

576 = Prepared as the dawn, כְּשַׁחַר כּוֹן, (Hosea 6:3) (This is a prophecy of the return of Jesus after "two days," – 2 thousand-year days. **"After two days He will bring us to life. In the third day He will raise us up, and we shall live before Him. Then we shall know, we who follow on to know the Lord. His going forth is *prepared as the dawn*."**) (These two days will be considered in the Time-Line of chapter five.)

576 = Six days, שֵׁשֶׁת יָמִים, (Exodus 19:9)

Thus it appears that the end of the six "days" of man's experience on earth is indicated by the number 576. It does not appear to be a coincidence that the Hebrew year 5760 begins where our time-line indicates the completion of 6000 years. On our calendar, the date for the beginning of the Hebrew year of 5760 is September 11, 1999.

No wonder the Eagle-Harp is ascending in songs of praise! It appears to mark the time when Jesus is exalted

to the long-promised throne of David – King Messiah!

The brightest star in this constellation is one of the most glorious in the heavens – it is *Vega*, meaning *He shall be exalted.* Moses used this word following the miraculous deliverance from the pursuing Egyptians by the parting of the sea, when he taught the Israelites to sing, **"I will sing to Jehovah, for *He is exalted."***

The Second Decan of Sagittarius – Ara

Ara is the picture of an altar or a burning pyre. It pictures the curse pronounced upon the enemy, Satan – the result of the final judgment. Ara pictures the final fate of Satan as is described in Revelation 20:10, **"And the devil that deceived them was cast into the lake of fire and brimstone, where the beast and the false prophet are."**

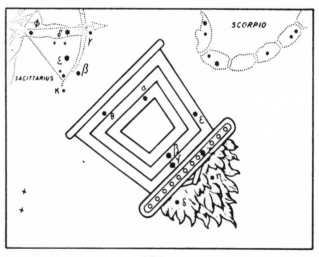

ARA

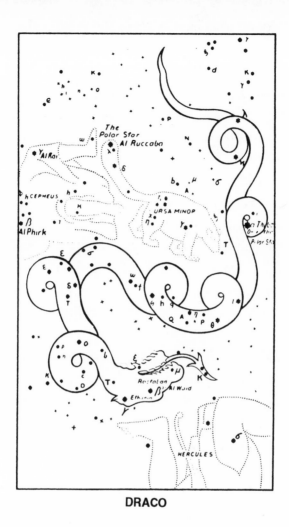

DRACO

The Third Decan of Sagittarius – Draco

Draco is a huge coiled serpent, wrapped around the celestial pole. Today, he is coiled around the North Star, Polaris, but at the time when these star pictures were given to Adam, the pole star was part of Draco. It was the bright star *Alpha Draconis*, whose ancient

Hebrew name was *Thuban, the subtle*. Its other bright stars are *Rastaban, the head of the subtle, Ethanin, the long serpent,* and *Giansar, the punished enemy.*

A coiled snake is one ready to strike, and Draco's position is coiled around the most northern place in the celestial sphere. It pictures Lucifer's attempt to usurp the authority of the universe. **"I will ascend to the sides of the north – I will be like the Most High,"** was his boast. But he has been wounded by the arrow of Sagittarius, and will ultimately experience the final judgment of the flames of Ara. Later, when we get to the 12th and last Zodiac sign, we will find Hydra, the fleeing serpent, no longer coiled to strike, but stretched all the way across the southern sky, in the act of fleeing. But he does not get away. His judgment is set.

Isaiah spoke of the final outcome of the serpent when he said, **"In that day the Lord with His sore and great and strong sword shall punish leviathan, the piercing serpent, even leviathan the crooked serpent, and He shall slay the dragon that is in the sea,"** (Isaiah 27:1 KJV)

Summary of Book I

The story of Book I of the Constellation Code is the story of the Redeemer. It begins with the promised "Seed of the woman," and the Babe of Bethlehem, the glorious Branch out of the "root of Jesse," the Desire of Nations. It portrays Him as the sin-offering for the sin of Adam, and as the ransom price to purchase all that Adam lost. It shows Him as the great Shepherd of the sheep, and as

the Coming One. He is seen as the Strong Man restraining the serpent who is attempting to grasp the Northern Crown. He is seen as Hercules, with His wounded heel, firmly holding the serpent in His left hand, with His other foot crushing the head of Draco, the coiled serpent, and wielding a fatal blow upon him with the club in His right hand. He is seen as the Archer, aiming His arrow at the heart of the scorpion. And finally He is seen as the Eagle-Harp, soaring upward in songs of triumph over Satan, and giving praise to Jehovah.

In all of these starry pictures, we see the Redeemer in His many roles, and in His many acts. It is a montage that describes *who He is.* Before any of these events happened, the story of the Redeemer was placed in the starry heavens for all to see. Surely, **"The heavens declare the glory of God, and the skies proclaim the work of His hands. Day after day they pour forth speech; night after night they display knowledge ... their voice goes out into all the earth, and their words to the ends of the world,"** (Psalm 19:1-4 NIV).

Book II, Chapter 1 – Capricornus

Book II of the Constellation Code is a magnificent story of the redeemed. Whereas in Book I we saw the story of the Redeemer, here in Book II we find the story of those whom He redeemed. The beginning of this story of the redeemed, is told in the first sign, Capricornus.

All of the ancient Zodiacs agree, this is the figure of the forepart of a dying goat, with a back part of a vigorous living fish. Thus it has come to be known as the Sea

Goat. There is, of course, no such thing in nature. But, for that matter, neither is there a centaur. In fact, the idea is the same in both creatures.

The centaur was a picture of the sin-offering. It being the forepart of a man and the backpart of a horse. It illustrated the fact that Jesus was, at one and the same time both a perfect man as well as bearing the sin of fallen man. As He died on the cross, He fully took the place of Adam and paid the price for Adam's sin. And now we find Capricornus, the Sea Goat is also a dual being – the front part is a dying goat, and the back part is a living fish. How better to illustrate the great truth that Jesus, the sacrificial goat of the sin-offering, by His very death, provided life for mankind. Those who obtain life through His death are represented by the fish. They are *the redeemed.*

It is well known that the early Christians were identified by the symbol of a fish. To this day they wear it as a symbol of their identity with Christ. They took the

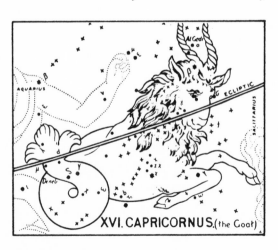

XVI. CAPRICORNUS.(the Goat)

acronym ICHTHUS as their code word. It is, in fact, the first letters, in Greek, of the title Jesus Christ, Son of God, Saviour. But the word *ichthus* is also the Greek word for *fish*.

As we saw in the Number Code, the number 8 represents a New Beginning through Jesus Christ, while the number 37 is the prime factor in most of His titles. And it is not surprising to find, in Hebrew, that the use of these two numbers relate to the fish.

$$8 = \text{Fish, } \text{דאג}$$
$$37 = \text{Like a fish, } \text{כדגי}$$

Capricornus is at once both the sacrificial goat of the sin-offering, and the means of rebirth. The brightest star in this constellation is *Al Gedi, the goat*. The next brightest is called *Deneb Al Gedi, the sacrifice coming*.

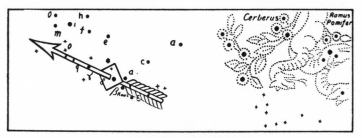

SAGITTA, THE ARROW

The First Decan of Capricornus – The Arrow

The Arrow, or Sagitta, is alone in its flight. We do not see the bow from which it is shot. It represents the arrow of divine justice and condemnation upon sin. The execution it accomplishes is shown by the dying goat.

This arrow of divine justice bears the two numbers of Beginning and New Beginning.

108 = Arrow, חץ

108 = He was pierced, מחלל, (Isaiah 53:5) **"He was pierced for our transgressions, He was crushed for our iniquities; the punishment that brought us peace was upon Him, and by His wounds we are healed,"** (NIV)

The Second Decan of Capricornus – Aquila

Aquila is a pierced and dying eagle. An eagle is the natural enemy of the serpent. We saw the soaring eagle-harp, rising up with a victory song. But in Aquila we see Him pierced by the arrow of divine justice, and dying.

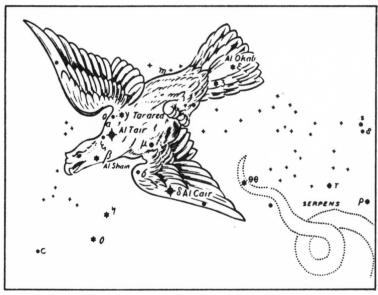

AQUILA

"We see Jesus ... now crowned with glory and honor, because He suffered death so that by the grace of God He might taste death for every man," (Hebrews 2:9).

This is the story of Aquila. Its brightest star is *Al Tair*, which means *the wounded*. Its other bright stars are *Al Shain*, *the bright*, or *scarlet*, referring to His shedding of blood for us, and *Al Cair*, meaning *the pierced*.

The Third Decan of Capricornus – Delphinus

Here we see a vigorous dolphin, rising up. It is the redeemed people – that which was begun with the tail of Capricornus. Here it is shown as a complete fish, rising up, vigorous with life.

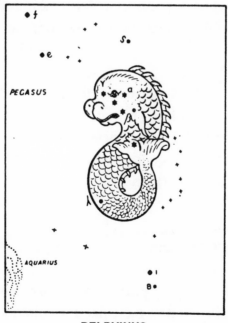

DELPHINUS

After Jesus' resurrection, He was standing one early morning by the shore of the sea. His disciples were in a boat nearby. They had been fishing all night and caught nothing. Jesus called to them to cast the net in again. This time it was filled with so many fish they could not haul it into the ship. After they made their way to shore, they drew in the net. It contained 153 fish.

Most Bible scholars agree that the event was symbolic. It represented the work that the disciples were to begin, becoming "fishers of men." The 153 fish in the net was symbolic of the company of believers who would be harvested. Their relation to Jesus is the relationship of the redeemed to the Redeemer; therefore it is not surprising to find that the number of the fish, multiplied by the number which represents a New Beginning in Jesus Christ, 8, would produce the number for *fishes* (plural).

$$8 \times 153 = 1224$$

$$1224 = \text{Fishes, } \iota\chi\theta\upsilon\varepsilon\varsigma$$

$$1224 = \text{The net, } \tau o \ \delta\iota\kappa\tau\upsilon o\nu$$

It was through His sacrificial death for Adam, that the way to life was opened. He said, **"I am the Way, the Truth, and the Life,"** (John 14:6)

$$1224 = \text{I am the Way}$$

$$1224 = \text{Way, Truth, Life}$$

It was for this very purpose that He came into this world. He came to pay the price for Adam's sin, and become the Way of life for Adam's posterity. His life on

earth, from His birth to His death, was 12240 days. Indeed He was the Way, the Truth and the Life!

Summary of Capricornus

The story of Capricornus is the dying goat giving birth to the fish. It is another illustration of the sin-offering. The Decans tell the story. The Arrow of divine justice exacts the price for Adamic sin. The Eagle, having borne the sin, now dies – the exchange of the Second Adam for the first Adam. And this gives birth to Delphinus, the fish, who represents all who have been redeemed. **"As in Adam all die, so in Christ all will be made alive,"** (I Corinthians 15:22).

Book II, Chapter 2 – Aquarius

This second chapter in the book of the redeemed tells the beautiful story of the water bearer. Its latin name means *The Exalted Waterman*. He holds a large urn, or bucket, from which flows the water of life. At the bottom of this abundant stream is a large fish, obviously drinking and swimming in the water. The brightest star in this sign is *Sa'ad al Melik, record of the outpouring*.

In some of the ancient Zodiacs only the urn appears, with the water pouring forth. The Hebrew name for this sign is *Deli*, which means *an urn* or *a bucket*.

A very ancient prophecy concerning the coming of Jesus refers to Him as the One pouring the water from His bucket. **"He makes water flow from His buckets, and His seed shall be in mighty waters,"** (Numbers 24:7). By adding the number equivalents for **"waters flow**

from His buckets" we get 180. It is the number that identifies Jesus – 1, the number of Beginning, and 8, the number of New Beginning. Thus He said, **"I am the Alpha and the Omega,"** – the 1 and the 800. This identification is further evidenced by the fact that there are 108 stars in this constellation.

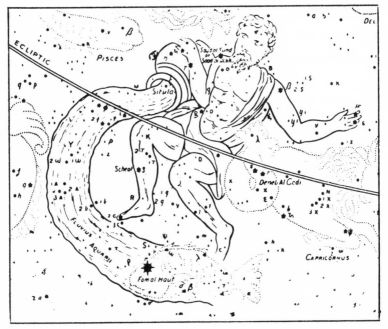

AQUARIUS

When the Israelites were in the wilderness, on their journey from Egypt to Canaan, Moses provided water for them by striking a special rock, and waters gushed out. It was a large flowing stream that was ample to satisfy not only the thirst of the people, but all their cattle as well. The Apostle Paul said that it pictured Jesus, from

whom we obtain the water of life.

"All did drink the same spiritual drink: for they drank of that spiritual Rock that followed (accompanied) **them; and that Rock was Christ,"** (I Corinthians 10:4). It is not merely coincidence that **"spiritual Rock,"** πνευματικης Πετρας adds to 1800.

Even the word "life" in Hebrew, חי, adds to 18. Isaiah prophesied that Jesus would be **"as streams of water in a dry place."**

Before Jesus left His disciples to return to His Father, He told them that He would have to go away, but that He would send the Holy Spirit to be a life-giving comfort and guide. The pouring out of the water from the urn also pictures the pouring out of the Holy Spirit upon the redeemed. And it is not a coincidence that the Holy Spirit, πνευμα το αγιον, adds to 1080. The 1 and the 8 represent life – life from the Beginner (1) and life from the New Beginner (8).

The First Decan of Aquarius – The Southern Fish

How could a picture be more obvious! The Fish is the recipient of the water that is being poured out. It represents the redeemed – those who drink the life-giving water. The Arabic name for this sign tells us that this fish is not just swimming in the stream, it is drinking it – *Fom al Haut* means *the mouth of the fish*.

The Second Decan of Aquarius – Pegasus

Pegasus is the front part of a horse who has wings. His name means the *horse of the gushing fountain*.

The bright stars in this constellation tell the story: *Markab, the returning; Scheat, he who goeth and returneth; Enif, the Branch; Al Genib, who carries; Homan, the waters; Matar, who causeth the plenteous overflow.*

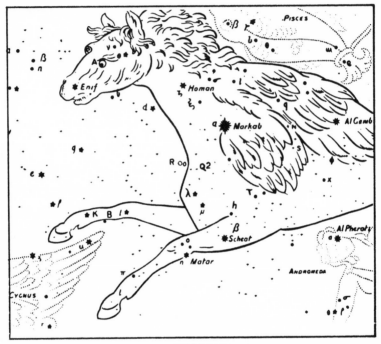

PEGASUS

This horse is not only rushing forth at an obvious gallup, but his speed is further enhanced by wings. It is a picture of the return of Jesus. He returns with life-giving water for a thirsty world.

King Solomon, whose reign was a picture of the promised Kingdom of Peace, wrote, **"He shall descend like rain on the mown grass, like showers that water**

the earth," (Psalm 72:6). The prophet Hosea wrote in similar pictorial language about the rain that would come down – showers of blessing at the return of Jesus. He said, **"His going forth is established as the dawn; and He shall come to us as the rain, as the latter and former rain to the earth,"** (Hosea 6:3).

Encoded into Hosea's prophecy are many exciting evidences of the return of Jesus. More of these will be discussed in the next chapter, however, for now I want to show its beautiful relationship to the constellation of Pegasus. The time element is given in the plain text. He promises to return after two days, **"in the third day."** Then he explains, **"His going forth is established as the dawn."** He has reference to the dawn of the third day, the Millennial day. However, the numeric value of this statement is 792, which has reference to the earth, and to Jesus who brings salvation to the earth. Look at the numbers. They are amazing!

792 = His going forth is established as the dawn,
 כשחר נכון מצאו
792 = Lord Jesus Christ, אלהא יהושרע משיח
792 = He is salvation, ישרעות, (Genesis 3:20)
792 = Salvation, ישרעות, (Psalm 116:13)
7920 miles – Diameter of the earth, the *place* of
 salvation.

The life giving benefits of this rain are spoken of again by the prophet Joel. The plain text tells of the rain, and the encoded text tells of its world-wide effects.

"He has given you the former rain according to righteousness, and He will cause the rain to come down for you, the former rain, and the latter rain," (Joel 2:23) Encoded within the text we find the circumference of the earth, showing that this is the place of salvation – this is the place where He will cause to come down the rain, the water of life.

248832 = He will cause the rain to come down for you, ויורד לכם גשם, (by multiplication)
24883.2 miles – Circumference of the earth

Although we have waited nearly 2000 years for His return, Pegasus is shown as coming swiftly. This swiftness is spoken of in the prophecy of Malachi: **"And the Lord whom you seek, shall suddenly come to His temple, even the Angel of the Covenant (Jesus) in whom you delight, behold He comes,"** (Malachi 3:1). By adding all the number values of the letters in this text, we obtain a total of 5184. It shows the beautiful harmony of the Number Code with the plain text, for it is the same number as can be found in the above prophecy of Hosea: **"He shall come as the rain,"** which multiplies to 5184.

Pegasus, the swiftly flying horse, comes with refreshing waters of life to a thirsty people. It is comforting to realize that Pegasus comes swiftly. We have waited nearly 2000 years for the promise that Jesus gave His disciples before he left them – He promised that He would come again, and take them to be with Him. His return has not seemed swift to His waiting people. But

in God's pre-set schedule, He comes right on time, with no delay. The last words of Jesus, in the book of Revelation were, **"Behold I come quickly."** And we can reply, even as John replied, **"Even so, come, Lord Jesus."**

The Third Decan of Aquarius – Cygnus

The great cross of Cygnus, the Swan, appears to dominate the summer sky. It is sometimes called the Northern Cross. It depicts a great and graceful swan in flight. The swan is the king of all the water birds. It is the very emblem of dignity and grace. The Greek name for this swan means *circling and returning*. Its bright stars

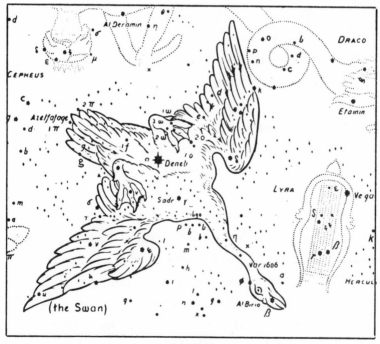

CYGNUS

are: *Deneb, the Lord to come; Azel, who goes and returns; Fafage, glorious shine forth;Sadr, who returns as in a circle; Adige, flying swiftly; Arided, He shall come down.* What a beautiful picture of the return of Jesus! He comes as the promised King. The Greek name for the Swan is πορφυριως, which means purple – the color of royalty.

This beautiful and graceful swan, a royal bird, bearing the stars of the Northern Cross, is also identified by its number:

2260 = Swan, πορφυριως
2260 = Son of Man, ο υιος ανθρωπου, (Matthew 20:18)
2260 = A shoot proceeds from the stump of Jesse and a Branch out of his roots will bear fruit. (Isaiah 11:1) (This is the verse, as we saw on page 59 that contains the hidden ELS Number Code 888. Jesus = 888).

Summary of Aquarius

Aquarius and its Decans tell an exciting story. It is the story of the pouring out of the water of life – life that was made available for Adam's race because Jesus has paid the price for Adam's sin, thereby releasing all from that sin's condemnation. It also pictures the pouring out of the Holy Spirit on the redeemed, which began on the day of Pentecost in A.D. 33, and will continue until all have received its joy and its power.

The Southern Fish is drinking in the life-giving water. It is the redeemed who drink.

The flying horse, the return of Jesus, comes swiftly,

bringing the water of life to a thirsty world. Jesus prophesied of the time when this water of life would be available to all. He stood up on the great day of the feast – the great eighth day following the seven days of the Feast of Tabernacles – and said, **"If any man thirst, let him come unto me and drink."** The seven days of the Feast of Tabernacles are emblematic of earth's great Millennium. At the end of that day, on the beginning of the great eighth day, we again find the words of Jesus – but this time He has appeared to John in a vision. He says: **"I, Jesus, have sent my angel to testify unto you these things … I am the root and the offspring of David, the bright and morning star. And the Spirit and the bride say, Come. And let him that heareth say, Come. And let him that is athirst come. And whosoever will, let him take the water of life freely,"** (Revelation 22:16, 17).

Book II, Chapter 3 – Pisces

Here we have the picture of two fish, tied together by another constellation called The Band. This Band is tied to the tail of each fish. It is folded in the middle, where it is attached to the dorsal fin of Cetus, the sea monster.

These fish still represent the redeemed, but now we see a division. One fish is going straight up, and its head actually becomes part of the constellation of Andromeda. The other fish is heading in the direction of the line of the ecliptic. Both represent the redeemed, but the one going north becomes part of Andromeda, the chained woman. It beautifully represents that group of the

redeemed who were espoused to Christ on the day of Pentecost in A.D. 33. It is a special company of the redeemed who have been developed during this past nearly 2000 years. They will be His bride. The marriage takes place when Jesus returns to take His bride to be with Him. This class of the redeemed were spoken of by the Apostle Paul when he said:

"For the Lord Himself shall descend from heaven with a shout, with the voice of the archangel, and with the trumpet of God: and the dead in Christ shall rise first: then we which are alive and remain shall be caught up together with them in the clouds, to meet the Lord in the air; and so shall we ever be with the Lord," (I Thessalonians 4:16, 17).

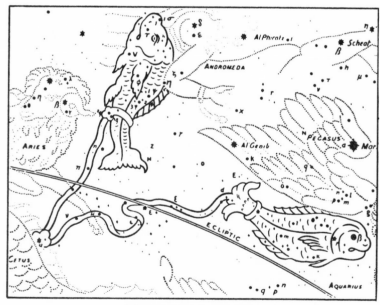

PISCES AND THE BAND

This special class is shown as separate from others of the redeemed. Jesus said, **"The hour is coming in which all that are in the graves shall hear his voice and shall come forth,"** (John 5:28). This includes all for whom He died. The Apostle Paul makes this very clear:

"Wherefore, as by one man (Adam) **sin entered into the world, and death by sin; and so death passed upon all men, for all have sinned ... so also is the free gift. For if through the offense of one** (Adam) **many be dead, much more the grace of God, and the gift** (life) **by grace, by one man, Jesus Christ, hath abounded unto many ... Therefore as by the offense of one** (Adam) **judgment came upon all men to condemnation; even so by the righteousness of one** (Jesus) **the free gift came upon all men to justification of life,"** (Romans 5:12-25).

Paul further explains this legal transaction when he said, **"As in Adam all die, even so in Christ shall all be made alive,"** (I Corinthians 15:22). Thus the redeemed are all of the Adamic race. But in this sign of Pisces, the special class who will be the bride of Christ is shown as a separate fish, heading north, becoming identified as Andromeda, the chained woman. As we will see in the next section of the Constellation Code, she represents the prospective bride, chained by Satan's attempts to destroy her.

The First Decan of Pisces – The Band

It may seem strange that amidst these starry symbols of fish, men, women, animals and serpents, that a simple band, or cord, would take a prominent place as

one of the constellations. By this Band, two fish are tied together. They have both received redemption through the death of Jesus, but they are held back from their forward pursuit by being attached to the dorsal fin of Cetus, the sea monster. But someone else also has hold of this Band. The forefoot of Aries, The Ram, is controlling it. Thus even though we are now held captive by the effects and wiles of Satan, yet we are also securely held by the redeeming work of Jesus, and are safe from the enemy's attempts to destroy us. Aries, who represents the resurrected and glorified Jesus, promises, **"I will make you strong; yea, I will help you; yes, I will uphold you with the right hand of My righteousness,"** (Isaiah 41:10).

The Second Decan of Pisces – Andromeda

Andromeda is a beautiful princess who sits chained at both arms and both legs. Some of the stars in this constellation are shared with one of the fish of Pisces, showing that they represent the same thing. She is the promised bride, but she sits in bonds – bound by the effects of Adamic sin, in her body of flesh, awaiting the coming of her Royal Bridegroom, who will release her and place her upon His royal throne.

The Third Decan of Pisces – Cepheus

Cepheus is a king, wearing a crown of stars, and holding in his hand a branch, or sceptre. He sits in repose, with his foot resting on the pole star. He pictures the glorified Jesus, who will soon come to unchain and

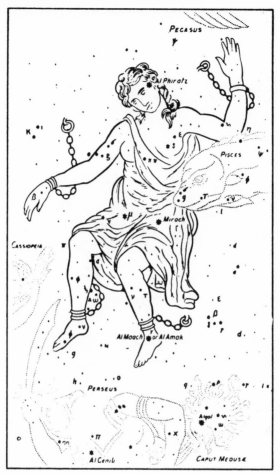

ANDROMEDA

claim His bride.

The names of the stars in this constellation identify him. In his shoulder is *Al Deramin,* which means the quickly returning one. In his belt is the bright star *Al Phirk, the Redeemer.* On his left knee is *Al Rai, the Shepherd.*

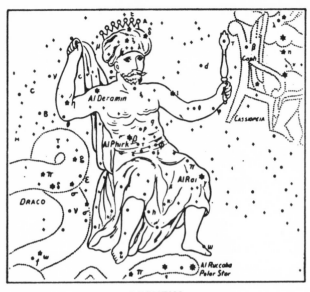

CEPHEUS

His name, Cepheus, means the royal Branch, the King. This identification was also given in the prophecy of Zechariah: **"The Man whose name is the Branch! He shall grow up out of His place, and He shall build the temple of Jehovah. Even He shall build the temple of Jehovah. And He shall bear the majesty and shall sit and rule on His throne,"** (Zechariah 6:12, 13). His identification is made obvious in the Number Code.

2368 = Jesus Christ, $I\eta\sigma o\upsilon\varsigma\ X\rho\iota\sigma\tau o\varsigma$

2368 = The Man whose name is The Branch, He shall grow up out of His place, and He shall build the temple of Jehovah.

שמר ומתחתיו יצמח ובנה את־היכל יהוה
איש צמח

Summary of Pisces

In this third chapter of Book II we see something special. It is the Bride. She first takes the form of a fish – having received redemption through the blood of Jesus. Then the fish becomes the chained woman, bound by her fallen human condition and the attacks of the enemy, Satan. But she has hope, for she can see her Bridegroom and King, Cepheus, and she knows that He will soon return, as He has promised, and take her to be with Him.

Book II, Chapter 4 – Aries (The Ram)

This last chapter in Book II is one of the most beautiful thus far in the Constellation Code, for it tells of the events of our day – events in the heavenly realm. For it is in this chapter that we see the chained woman transformed into Cassiopeia, the crowned queen, and at the same time we see the overthrow and binding of Satan. They are events that the prophets have foretold for the "last days." And here we are, A.D. 1999, expecting and looking diligently for the fulfilling of these prophecies.

This chapter begins with a Ram, a beautiful vigorous male sheep, whose front foot is controlling the Band that is tied to Cetus, the sea monster. The Hebrew name for this constellation is *Taleh, the lamb.* The chief star in this constellation is *El Nath*, which means *wounded* or *slain.* The next brightest star is named *Al Sheratan, the bruised, the wounded.*

In the sun's yearly trip through the Zodiac, it is in

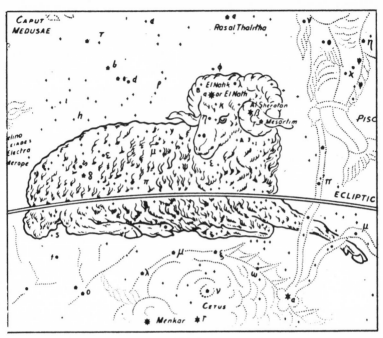

ARIES

Aries during the month of Nisan. Because of the preces-
sion of the equinoxes, it slips back slightly along the path
of the ecliptic. This backward movement requires 25,920
years to complete one cycle – the Great Year. Thus, in the
year in which Jesus died (A.D. 33), the sun was posi-
tioned, at noon, on the bright star *El Nath, the wounded,
the slain.* It was at noon that day that the sun was
miraculously darkened – so much so that the stars
appeared. And in that unnatural darkness, the faint
appearance of the sun could be seen directly in the head
of Aries, the Lamb of God.

God's timeclock is precise! We are told, **"When the**

fulness of time was come, God sent forth His Son,"
Galatians 4:4). And when God's appointed time had
come – Nisan 14, A.D. 33 – the Lamb of God was slain.
Just as assuredly, the preset time for His return will be
right on schedule, and will accomplish all that has been
promised.

The illustration of Aries, and its time setting, are
described in the book of Revelation. **"Worthy is the Lamb
that was slain, to receive power, and riches, and wis-
dom, and strength, and honour, and glory, and bless-
ing."** This is the glorified Jesus, coming in His role of
conqueror, the King on David's throne, who comes to
take His bride – one of the fish tied to the Band – and to
bind Satan, Cetus, who is also tied to the Band. **"And He
laid hold on the dragon, that old serpent, which is the
Devil, and Satan, and bound him a thousand years,"**
(Revelation 20:2). **"For the Lord Himself shall descend
from heaven with a shout, with the voice of the arch-
angel, and with the trumpet of God; and the dead in
Christ shall rise first; then we which are alive and
remain shall be caught up together with them in the
clouds, to meet the Lord in the air; and so shall we ever
be with the Lord,"** (I Thessalonians 4:16, 17). **"Let us be
glad and rejoice, and give honour to Him; for the
marriage of the Lamb is come, and His wife hath made
herself ready,"** (Revelation 19:7). Such is the beautiful
story of Aries.

The First Decan of Aries – Cassiopeia

The ancient legends say that Cepheus, the crowned

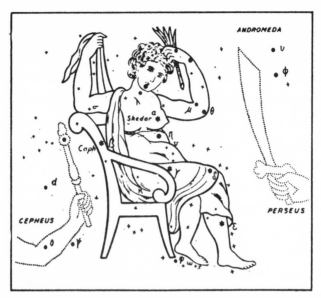

CASSIOPEIA

King, married Andromeda, the chained woman, and she became Cassiopeia, the enthroned queen. Legends can be made of strange stuff. But somewhere there is a seed-thought behind them.

Cassiopeia is a beautiful woman, seated with royal dignity, holding a branch of victory in her hand. The bright star in this constellation is *Shedar*, which means *the freed*. The next star is *Ruchbah, the enthroned*. She sits in a chair close to Cepheus, the King, and he is holding out his sceptre to her.

There is an interesting enactment of this picture in the Old Testament book of Esther.

"And it came to pass *on the third day* that Esther put on royal clothing and stood in the inner court of the king's house, before the king's quarters. And the

king sat on his royal throne in the royal house, in front of the gate of the house. And it happened, when the king saw Esther the queen standing in the court, she rose in favor in his eyes. And the king held out to Esther the *golden sceptre* that was in his hand. So Esther drew near and touched the top of the sceptre. Then the king said to her, 'What shall be done to you, O queen Esther? And what is your wish? It will be given to you also, even to half of the kingdom,' " (Esther 5:1-3).

All this took place on the "third day." On the 7000-year scale of human events, the seventh is also said to be the third, because it is third from the first coming of Jesus. Thus, in the beginning of the third day from the coming of Jesus to be man's redeemer, He sits as a crowned King. And it is on that third day that He, pictured in the Constellation Code as Cepheus, holds out His golden sceptre to Cassiopeia, and shares His kingdom with her.

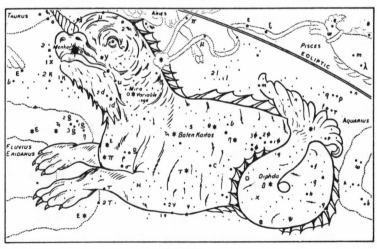

CETUS

The Second Decan of Aries – Cetus

Cetus is a giant sea monster who pictures Satan. This constellation is a graphic illustration of the binding of Satan at the time of the returning of Jesus for His bride.

Revelation 20 describes the scene: **"And he laid hold on the dragon, that old serpent, which is the Devil, and Satan, and bound him a thousand years."**

This event is also described in Psalm 74:13, 14, **"You broke the heads of the sea monster in the waters. You broke the heads of leviathan in pieces."**

The Third Decan of Aires – Perseus (The Breaker)

Perseus is shown as a warrior, holding high a sword in his right hand, and securely tucked under his left arm is the severed head of the enemy. This warrior has wings on his feet, indicating that he comes swiftly. His name is also called The Breaker, because the bright star in his left foot is *Athik*, which means *who breaks.* The bright star in the severed head is *Al Gol*, or in Hebrew it is called *Rosh Satan, the head of the adversary.*

The name Perseus is from the Hebrew *Perets – a break, or breach.* Its Hebrew letters, פרץ, add to 370 and multiply to 144. It is used prophetically of Jesus in Isaiah 58:12 **"and you shall be called the Repairer of the Breach, the Restorer of paths to live in."**

In Isaiah 28:21 the name is used again, and it is placed in the time period of Jesus' return and the destruction of Israel's enemies. **"For the Lord will rise up as He did at Mount Perazim; He shall be stirred as in the valley of Gibeon, to do His work, His strange**

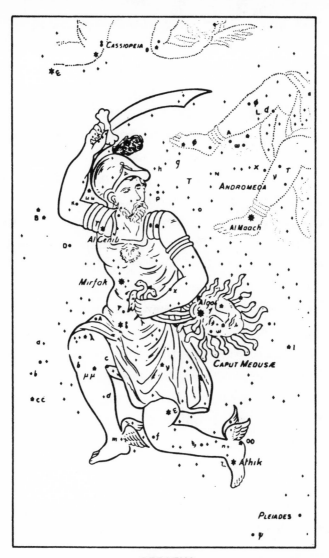

PERSEUS

work; and to perform His act, His strange act." So, what did God do at Mount Perazim that was so strange?

The story is found in II Samuel 5:17-20, and is an event that took place almost immediately after David

had been anointed king over all Israel, in the year 1002 B.C..

"And the Philistines heard that they had anointed David king over Israel; and all the Philistines came up to seek David; and David heard and went out to the stronghold. And the Philistines came and were spread out in the valley of Rephaim. And David asked of Jehovah, saying, 'Shall I go up to the Philistines? Will you give them into my hand?' And Jehovah said to David, 'Go up, for I will certainly give the Philistines into your hand.' And David came to Baal-Perazim, and David struck them there and said, 'Jehovah has broken (perez) forth on my enemies before me, as the breaking forth of waters.' Therefore he called the name of that place Baal-Perazim." The Number Code reveals that this was prophetic of the time of Jesus' return and the destruction of Israel's enemies. All of the numbers involved are consistent with the numbers used throughout the scriptures pertaining to the time of His return.

540 = Baal-Perazim
420 = Perazim (by addition)
576 = Perazim (by multiplication)
480 = As the breaking forth of waters

Note how these numbers relate to the time of Jesus' return and the beginning of His Kingdom. The number 42 is used over and over again in the book of Revelation regarding events at the beginning of the time of His return. It is spoken of as 42 months, or periods of 1260

days. There are two such periods of time, adding to a total of 2520 days, or seven prophetic years. They have to do with the time of Jacob's trouble and Armageddon. The other three numbers are shown below.

5040 = The Kingdom of our Lord and His Christ (Revelation 11:15)

5040 = Seventh Day (by multiplication) (Jesus returns at the beginning of the seventh millennium from Adam.)

5760 = Six days (by multiplication) (Jesus returns after the end of the six thousand years from Adam.

5760 = He shall appear in His glory (by multiplication) (Psalm 102:16)

5760 = Messiah the Prince (by multiplication) (Daniel 9:25)

4800 = The coming of the Son of Man (by addition) η παρουσια του υιου του ανθρωπου

480 = The Breaker has come up (Micah 2:13) (The Breaker is Perseus).

Long before David's time, the prophet Balaam spoke a strange prophecy of the "last days." **"I shall see him, but not now; I shall behold him, but not near: A Star shall come forth out of Jacob; and a Sceptre shall rise out of Israel."** (Numbers 24:17) It is a prophecy of the time of the "last days," when Jesus will come as the King on David's throne. It bears the same numbers as David's victory at Baal-Perazim, and both are prophetic of Jesus' victory over Israel's enemies at His return.

48 = Star, כוכב (by addition)
4800 = Star, כוכב (by multiplication)
54 = Sceptre, שבט (by multiplication)

Perseus, The Breaker, is also spoken of by the prophet Micah, when speaking of the time of Jesus' return and His saving Israel from their enemies. **"I will surely gather all of you, Jacob; I will surely gather the remnant of Israel ... The Breaker has come up before them; they have broken up and have passed through the gate and have gone out by it. And their King shall pass through before them, and Jehovah at the head of them,"** (Micah 2:13)

Micah placed the name "The Breaker" into a statement of action – **"The Breaker has come up."** The addition of its letter-numbers totals 480. It is prophetic of the time of Jesus' return. **"The coming of the Son of Man"** also equals 4800 (Matthew 24:27) Both statements are prophetic of the same event, and they both bear the number, 480.

This third Decan of Aries is a beautiful picture of the return of Jesus, and it is comforting to know that He has wings on His feet. The last words that He has left His church were, **"Yes, I am coming quickly,"** (Revelation 22:20).

In recent years a strange phenomenon has occurred in Perseus. It may possibly be a "sign" for those who are watching for Jesus' return.

On the night of April 11, 1996, the comet Hyakutake was positioned precisely over the star *Al Gol*, which is

on the severed head that Perseus holds under his left arm. Then, on the night of April 11, 1997 (exactly one year later) the comet Hale-Bopp was also positioned precisely over *Al Gol*. The paths of these two comets came at right angles to each other, forming a cross on the forehead of the severed head of Satan. That the paths of these two comets crossed at right angles precisely over *Al Gol*, and precisely one year apart, is astounding! Was it a "sign?" We are told in scripture that the stars were to be for signs; and we are also told that there would be signs in the heavens regarding the time of Jesus' return. This phenomenon is made even more spectacular by the fact that again, precisely one year later – on April 11, 1998 – was Passover. It was the anniversary of the day that Jesus hung on the cross, and died. The chances against this having been sheer coincidence are astronomical. (No pun intended.)

Summary of Aries

Aries is a beautiful story of the return of Jesus, who puts leviathan in bonds, and lifts the chained Andromeda to the royal throne of Cassiopeia. He comes as The Breaker, the one who conquers the enemies of Israel, and the only one found worthy to "break" the seals of Revelation 6. **"And I saw when the Lamb opened** (ηνοιξεν = 420 by multiplication) **one of the seven seals, and I heard, as it were the noise of thunder ... And I saw, and behold a white horse: and he that sat on him had a bow; and a crown was given unto him; and he went forth conquering and to conquer."** It is a word picture

of the going forth of one who usurps the rulership of earth, but he does not conquer, for The Breaker comes up against him.

Summary of Book II

Thus ends the story of Book II of the Constellation Code. This second book, like the first, contains four chapters, at the conclusion of which, the sun will have made its way through two-thirds of the circuit of the Zodiac. The entire circuit requires 25,920 years. Each book, or third, is represented by the solar number 864 (diameter of the sun is 864,000 miles). Thus two thirds of 2592 (or two times 864) is 1728. When the sun has completed its journey through this second book, it will have traveled 17,280 years. I mention this because the number seems so appropriate here, where Jesus is pictured as the Root and Offspring of David, saying to all mankind **"Whosoever will, let him take the water of life freely."**

1728 = I am the Root and the Offspring,
(Revelation 22:16)
1728 = Proclaim, κηρυσσω, (a public proclamation of the gospel)
1728 = Holy Jerusalem, αγιων Ιερουσαλημ,
(Revelation 21:10 – this is the New Jerusalem)

And, by multiplication we observe the following:

1728 = I am the Alpha and the Omega, εγω Αλφα και Ωμεγα

1728 = The day of His coming, יום בואו,
(Malachi 3:2)

1728 = I will be exalted in the earth, ארום בארץ
(Psalm 46:10)

1728 = Come to the water, לכו למים, (Isaiah 55:1)

This second book shows the water of life which will be available to all. The Hebrew word for "life", חי, has a numeric value of 18 – the 1 and the 8 representing the Beginning and the New Beginning through Jesus Christ. Thus it is fitting that the numbers in the one who pours out the water, Aquarius, also adds to 18.

792 – 7 + 9 + 2 = 18
5184 – 5 + 1 + 8 + 4 = 18
1728 – 1 + 7 + 2 + 8 = 18

Book III, Chapter 1

This book contains the last four Zodiac signs – Taurus, Gemini, Cancer, and Leo. The story it tells is the magnificent fulfillment of all the promises of God – the promises of redemption and a New Beginning through Jesus Christ.

Chapter 1 of this last book is pictured as the forepart of a bull, rushing forward with his horns in attack posture. Although this sign is commonly called The Bull, the animal depicted is much more fierce and powerful than an ordinary bull. It is, in fact, the now extinct reem, a fierce and powerful wild ox that once inhabited the Middle East, western Asia, and eastern Europe. It was

comparable to an elephant in size, and was particularly distinguished for its great sharp horns. Thus Jesus, at His return, is pictured in Psalm 92:10 as a reem: **"But you will lift up my horn as the reem."**

Only the front part of this animal is shown; the hinder part is Aries, who we have just seen is a picture of the glorified Jesus, the Lamb of God. Taurus is exactly opposite the Scorpion in the circle of the ecliptic, so that when Taurus is visible in the sky, the Scorpion disappears from view.

The brightest star in this constellation is the eye of this fierce creature, *Al Debaran*, meaning *leader* or *gover-*

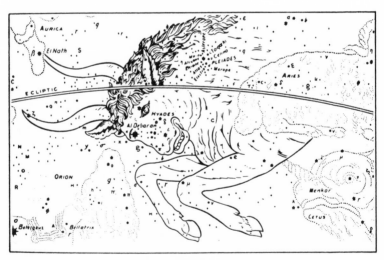

TAURUS

nor. It is the origin of our common term "bull's eye."

This mighty and fierce reem is a fitting picture of the second coming of Jesus. He comes *with* His saints (probably represented by the Pleiades which is within the neck of the reem), as is described in Revelation 19. Immediately following the marriage of the Bride and the Lamb, they are described as coming to make war with the forces of evil.

"And behold a white horse; and he that sat upon him was called Faithful and True, and in righteousness he doth judge and make war ... And he was clothed with a vesture dipped in blood; and his name is called The Word of God. And the armies which were in heaven (the bride) **followed him upon white horses, clothed in fine linen, white and clean. And out of his mouth goes a sharp sword, that with it he should smite the nations; he shall rule them with a rod of iron; and he treads the winepress of the fierceness of the wrath of Almight God,"** (Revelation 19:11-15).

Isaiah prophesied of this event, and put it in graphic language, much of which I leave out, because it is lengthy:

"Jehovah's wrath is on all the nations, and his fury on all their armies ... he has delivered them to the slaughter ... a sword is to Jehovah, it is filled with blood; it is made fat with fatness, with the blood of lambs and goats ... for Jehovah has a sacrifice in Bozrah, and a great slaughter in the land of Edom. And the reem shall come down with them ... for the day of vengence is to Jehovah, the year of repayments for Zion's cause," (Isaiah 34:2-8).

The First Decan of Taurus – Orion

There has been disagreement among those who interpret these signs as to the meaning of Orion. This is due to the fact that in some illustrations he is pictured holding a drawn bow, with its arrow aimed at Taurus. In the older Zodiacs, however, Orion is pictured as holding a club in his right hand, and a token of his victory – a lion's skin – in his left hand.

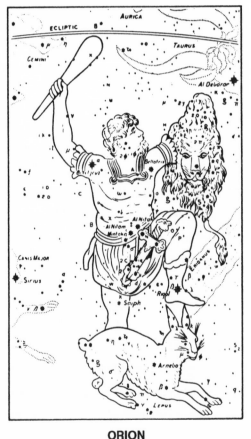

ORION

The name Orion means *he who comes forth as light, the Brilliant, the Swift*. The bright star in his right shoulder is *Betelguese*, which means *The Branch coming*. (I can never forget the name of this star because my son used to call it "beetle juice.")

In Orion's left foot is the bright star *Rigel*, which means *the foot that crusheth*. And surely this foot is in the act of crushing Lepus, the hare.

Orion pictures the returned Jesus, in His role of victor over Satan and evil. This is why God asked Job, **"Can you bind the bands of the Pleiades, or loosen the cords of Orion?"** The obvious answer is "No." Because the identifying number is in the word "loosen," תפתח, 888, which power resides in Jesus, *Ιησους*, 888.

The Second Decan of Taurus – Eridanus

From beneath the left foot of Orion flows the terrible river of fire, Eridanus, meaning *river of the Judge*. It is spoken of in Psalm 97, **"Righteousness and judgment are the foundation of his throne. A fire goes before him and burns up his enemies."**

The river flows from the downward coming foot of Orion and follows a serpentine course, down, down, and out of sight. Daniel saw this river in the vision of the Ancient of Days: **"A fiery stream issued and came forth from before him,"** (Daniel 7:9-11). The prophet Habakkuk saw the same thing and described it as the coming of the Lord – **"His brightness was as the light … and burning coals went forth at his feet,"** (Habakkuk 3:5). It is a picture of the final judgment upon Satan and

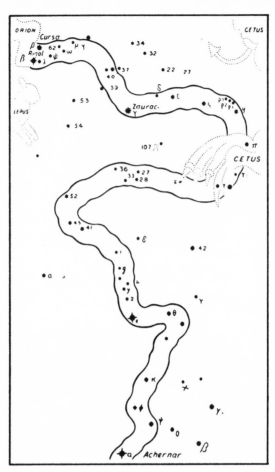

ERIDANUS

the nations who follow him. And in the Constellation
Code, Cetus, the sea monster, is shown with his two feet
plunged into this river of fire.

The Third Decan of Taurus – Auriga

Auriga is a kindly shepherd, seated, with a goat and
her two young kids securely held in his arm. Auriga is

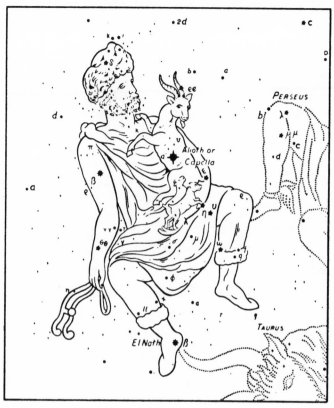

AURIGA

that same Good Shepherd who gave his life for his sheep.

Placing Auriga in the time-setting of Taurus, the time of judgment, might at first seem out of place, but Isaiah described it beautifully: **"Behold, the Lord God will come with strength, and His arm rules for Him. Behold, His reward is with Him and His wage before Him. He shall feed His flock like a shepherd; He shall gather lambs with His arm; and in His bosom carry them; those with young He will lead,"** (Isa. 40:10-11).

The Apostle Peter spoke of the time of Jesus' return with these words: **"When the Chief Shepherd shall appear, ye shall receive a crown of glory that fadeth not away,"** (I Peter 5:4).

The picture of Auriga cuddling the goats in his arm, protecting them from the forward rush of the horns of the reem, seems to say that those who belong to the Chief Shepherd will be **"saved from the wrath to come."** They will be safe with Him during the great tribulation.

Summary of Taurus

In Taurus we see the return of Jesus, waging war against Satan, and conquering him. We see the river of fire that burns up the enemy, and we see the deliverance of the Bride, safely escaping the wrath that comes upon the earth. Taurus shows both the fierceness of His wrath upon the adversaries of His kingdom, and the tender gentleness of the Shepherd gathering his little ones into his arm.

Book III, Chapter 2 – Gemini

Gemini is usually thought of as being the Twins; its chief stars being *Castor* and *Pollux*. It is usually pictured as identical twins sitting together. However, in the Zodiac of Dendera, it is a man and a woman. They are sometimes called Adam and Eve; however, not the Adam and Eve in the Garden of Eden, but the Second Adam and His bride. He is the glorious King, whom we saw as Cepheus, sitting enthroned with His bride, the illustrious queen Cassiopeia.

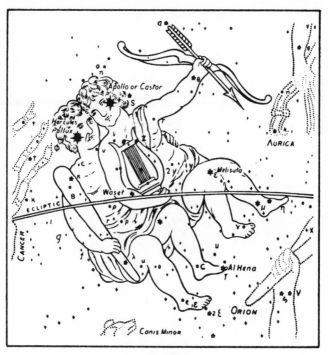

GEMINI

The Hebrew name for this constellation is *Taumim*, taken from the word *tawam*, meaning *joined together* or *coupled*. The old Coptic name was *Pi Mahi*, meaning *the united*, or the *completely joined*. It beautifully pictures the oneness of Jesus and His bride following the heavenly marriage. It is God's sign in the heavens of that blessed union, the promise of which was confirmed on Pentecost of A.D. 33, and soon to be consumated in the glorious heavenly realm. **"Let us be glad and rejoice, and give honor to him; for the marriage of the Lamb has come, and his wife has made herself ready,"** (Revelation 19:7).

The First Decan of Gemini – Lepus

Lepus is shown as the figure of a hare. In some of the ancient Zodiacs it is shown as a serpent. In any case, it is positioned directly under the down-coming foot of Orion, who is about to crush it. A hare is a defenseless animal. And this is the condition of the enemy, Satan, when he is bound. It aptly portrays the approaching end of the enemy, once the heavenly marriage is celebrated.

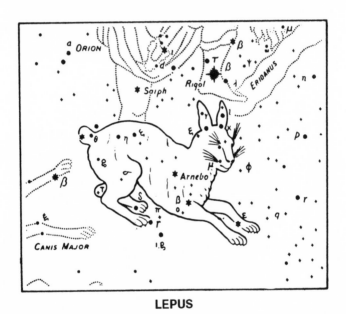

LEPUS

The Second Decan of Gemini – Canis Major

This constellation contains the brightest star in the heavens – *Sirius*. The only things brighter are the planet Venus and the moon. The name *Sirius* comes from *Seir*, which means *Prince*, or *Guardian*. The Egyptian name is *Naz-Seir*, meaning *the sent Prince*. This is called *Netzer*,

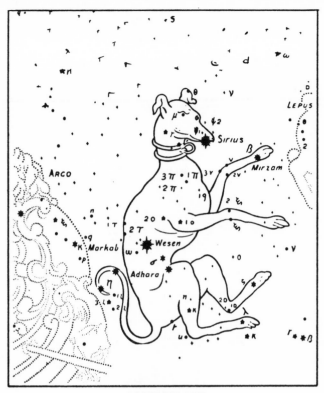

CANIS MAJOR

נצר, in Hebrew, which is translated "The Branch." **"A Rod proceeds from the stump of Jesse (David's father), and a Branch *(Netzer)* will bear fruit out of His roots,"** (Isaiah 11:1). It is clearly prophetic of Jesus.

The prophecy that He should be called a *Naz-Seir-ene* has a far deeper meaning than that He would grow up in the town of Nazareth. It is a play on words that also relates to the vow of the Nazarite. And it includes the idea of His position of rulership at His return. But following the marriage, He does not come alone. Canis Major has a companion – Canis Minor.

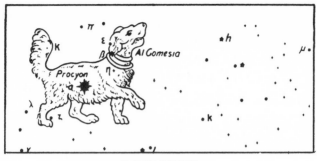

CANIS MINOR

The Third Decan of Gemini – Canis Minor

This heavenly scene has been so beautifully described by Joseph Seiss[1] in *The Gospel in the Stars*, that I would like to quote his words.

> But when the glorious Sun of Righteousness thus comes forth in His majesty from under the wedding canopy … He comes not alone. The armies of the heaven follow Him on white horses, wearing the clean linen of saintly righteousness. He is the Head, the Leader, the Chief, but behind Him are His elect myriads, warrior-judges, like himself. He is married now, and His bride is with her Husband. "To execute vengeance upon the nations, and punishments upon the people; to bind their kings with chains, and their nobles with fetters of iron; to execute upon them the judgment written: this honor have all the saints," (Psalm 149:7-9.

The bright star in Canis Minor is *Procyon*, which

1 Joseph Seiss, *The Gospel in the Stars*, Kregel Publications, Grand Rapids, 1972, p. 118.

means *the redeemed.* The next brightest star is *Al Gomeyra,* which is *who completes or perfects.*

Book III, Chapter 3 – Cancer

In our modern Zodiacs, Cancer is depicted as a Crab. But this is not so in the ancient Zodiacs. Its Arabic name is *Al Sartan,* which means *who holds or binds.* In Hebrew it is the word אסר, meaning *to bind together.* Thus we come to the completion of His work – the binding together of the precious possessions, the redeemed. This is beautifully shown in the three Decans.

The First Decan of Cancer – Ursa Minor

Ursa Minor is the Little Bear, but we sometimes give it the modern appellation of Little Dipper. It is, in fact, not a bear at all, for no bear has the long tail that is pic-

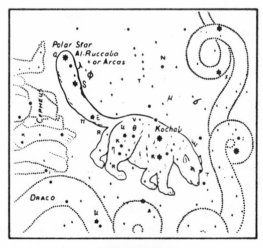

URSA MINOR

tured here. It more properly pictures the *Sheepfold*, or the place of ingathering of the flock. This constellation is connected to the Pole Star, the very central star in the heavens, around which all the others revolve.

The brightest star in this constellation is *Al Ruccaba*, which means *the turned* or *ridden on*. And Today it is indeed the star on which all of the heavens turns, or revolves.

The two bears, Ursa Minor and Ursa Major represent two sheepfolds, the resting places of the flocks. The smaller sheepfold, whose position is in the celestial north, pictures the heavenly sheepfold. Jesus called them a **"little flock."**

God's promise to Abraham was **"I will bless you, and I will multiply your seed like the stars of the sky, and like the sand which is on the seashore,"** (Genesis 22:17). And these two sheepfolds picture, the smaller number (the stars of the sky), and the larger number (the sand upon the seashore).

The Second Decan of Cancer – Ursa Major

This greater sheepfold is the final rest of the multitudes of the seed of Abraham, pictured by the sand of the seashore. The brightest star in this constellation is *Dubheh*, which means *a fold*, or a place of rest for a group of domestic animals.

Ursa Major is commonly called the Big Dipper, because its brightest stars appear to outline the shape of a dipper. Throughout most of the ages of man, this constellation has shown the way to the north star – the Pole

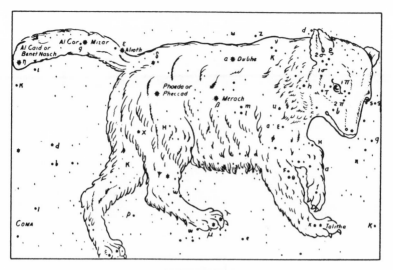

URSA MAJOR

Star. It is our means of orientation to north, for the alignment of its two bright stars in the cup of the dipper point to the Pole. Thus the larger sheepfold, the earthly seed of Abraham, will point the way for the remainder of mankind in God's great Millennial day: **"And they shall declare My glory among the nations** (Gentiles)," (Isaiah 66:19).

The Third Decan of Cancer – Argo

Argo means *a company of travelers.* It is depicted by a ship which brings the weary travelers home, to their resting place. Its brightest star, *Canopus,* means the *possession of Him who cometh.* And surely they are His possession, for He purchased them with His own precious blood. We have the assurance that **"as in Adam all die,**

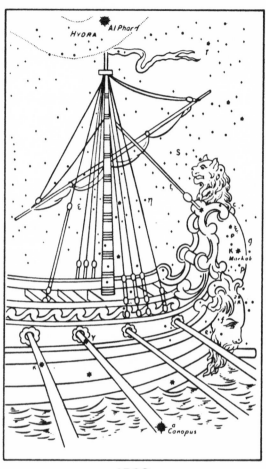

ARGO

so in Christ shall all be made alive," (I Corinthians 15:22). And this includes all, both Israelite and Gentile. Thus I suggest that Argo pictures the bringing in of the Gentile world, into the Millennial Kingdom of God.

Summary of Cancer

The Hebrew name for this constellation, אסר,

meaning *to bind together*, is shown in its three Decans. It is the binding, or bringing together, of all things into the fold. The Apostle Paul spoke eloquently of this in his letter to the Ephesians:

"... to the praise of the glory of His grace, wherein He hath made us accepted in the Beloved ... that in the dispensation of the fulness of times He might gather together in one *all things* in Christ, both which are in heaven, and which are on earth, even in Him," (Ephesians 1:6-10).

432 = All things, $\pi\alpha\nu\tau\alpha$

432 = The habitable world, תבל, (I Samuel 2:8)

432 = Our peace, שלומנו, (Isaiah 53:5)

432 = The Branch of Jehovah, beautiful and glorious, (Isaiah 4:2) (This beautiful name for Jesus both adds and multiplies to 432.)

432 = He shall lead them by springs of water, (Isaiah 49:10)

432 = All nations, כל-גוים, (Psalm 72:11)(by multiplication)

432 = Jerusalem, ירושלם, (by multiplication)

4032 = Holy Jerusalem (New Jerusalem), $\alpha\gamma\iota\alpha\nu\ I\varepsilon\rho o\upsilon\sigma\alpha\lambda\eta\mu$, (Revelation 21:10) (by multiplication)

4032 = Kingdom of heaven, $\beta\alpha\sigma\iota\lambda\varepsilon\iota\alpha\ \tau\omega\nu\ o\upsilon\rho\alpha\nu\omega\nu$, (Matthew 13:47 (by multiplication)

The Number Code tells the story of the ingathering of all into the Kingdom of God.

Book III, Chapter 4 – Leo

This closing chapter in the book of the Constellation Code is about the Lion of the Tribe of Judah – Jesus Christ – and it is all about finality. This lion is not in repose, he is a lion in the act of hunting down his prey. Its Arabic name is *Al Asad*, which means *a lion leaping forth as a flame*. The Hebrew word is לבאים, which is used to denote *a roaring lion*. It pictures Jesus, the Lion of the Tribe of Judah, from the time He takes the throne of David, at His coming, until all enemies are destroyed and cast into Eridanus, the river of fire, as described in Revelation 20:1-10. **"… and He laid hold on the dragon, that old serpent, which is the Devil and Satan, and bound him a thousand years … that he should deceive**

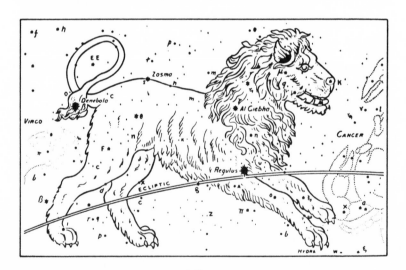

LEO

the nations no more, till the thousand years should be fulfilled ... and when the thousand years are expired, Satan shall be loosed out of his prison and shall go out to deceive the nations ... and the devil that deceived them was cast into the lake of fire ..."** This is the work of Leo.

The Lion's work begins at His return. Following the rapture scene, the Apostle John saw in vision the Almighty, holding in His hand a scroll, written within and without, and sealed with seven seals. The scroll was the title-deed to the inheritance of life, which had been forfeited by Adam. This title-deed was now in the hand of God, to whom the human race, through Adam, had become indebted. John wept when he saw that no man had been, or ever would be, worthy to break the seals and receive the inheritance. Then a voice said to him, **"Weep not, behold, the Lion of the Tribe of Judah, the Root of David, hath prevailed to open the scroll, and to break the seals thereof,"** (Revelation 5:5).

We have seen in the constellation of Perseus that Jesus comes, at His return, as The Breaker, and He is the One found worthy to break the seals and to open the scroll. He will be the One to restore to man the title-deed to everlasting life.

The First Decan of Leo – Hydra (The Fleeing Serpent)

Back in the Garden of Eden, roughly 6000 years ago, God proclaimed the inevitability that the "seed of the woman" would bruise the serpent's head. The whole story of the Constellation Code has been the conflict

between Jesus and Satan – and here we have the final *coup-de-gras*, for Leo is a roaring lion rushing forth, and leaping upon the head of Hydra, who is attempting to flee.

Hydra, in his attempt to flee, has stretched the length of his writhing body all the way across the southern sky. He is in the south because he has been cast out of the north. He had been Draco, who was coiled around the Pole Star, to grasp the position from God. A coiled serpent is positioned to strike, but a serpent stretched out cannot strike. He knows his doom is near, and he attempts to flee, but to no avail. There is no place to hide. **"In that day the Lord will punish with his sword, his fierce, great and powerful sword, Leviathan, the fleeing serpent ... he will slay the monster of the sea,"** (Isaiah 27:1)

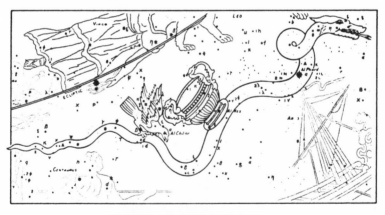

HYDRA, CRATER, CORVUS

The Second Decan of Leo – Crater

Crater is the Cup of Wrath. It is pictured as a large cup full of red wine. The cup not only rests on the body of Hydra, it shares some of the same stars with Hydra. It is the cup of God's wrath poured out upon Satan and evil. It will be the great crushing Leo who **"treads the winepress of the fierceness and wrath of Almighty God,"** (Revelation 19:15). This restraining of Satan is first a binding, or imprisonment, then finally it will be destruction in the lake of fire.

The Third Decan of Leo – Corvus

Corvus is a raven – a bird of prey. It is the natural enemy of the serpent. Birds of prey not only kill a serpent, but they also devour it until there is nothing left. And this is precisely the picture of Corvus. It is the final act of Leo in conquering Satan. Corvus eats him up!

Summary of Leo

Leo, the roaring Lion, leaping on its prey, tells the story of Jesus, as the Lion of the Tribe of Judah, saving His people, Israel, and eventually casting Satan into the lake of fire. The prophet Isaiah described it graphically:

"As a lion growls, a great lion over his prey ... so the Lord Almighty will come down to do battle on Mount Zion and on its heights. Like birds hovering overhead the Lord Almighty will shield Jerusalem; He will shield it and deliver it," (Isaiah 31:4).

This will be near the beginning of the great Millennial day when God will save Israel from her

enemies; but at the end of the Millennium, He will destroy Hydra, the fleeing serpent.

Thus the Constellation Code will be completed. It has told its story. It began with Virgo and traverses the full circle of the ecliptic with its grand finale in Leo, telling the story of the redemption of man and the conquering of the enemy, Satan. It is emblazoned across the sky every night. And every time we look up into that starry display, we can have confidence that God indeed has a plan for the redemption of man from the condemnation in Adam, and that His plan includes the blessing of **"all the families of the earth"** just as He promised to Abraham. We live at a very special time in the progression of that plan, for the dawn of the great Millennial day is upon us!

Each year the sun makes its annual circuit through the Zodiac, but with each circuit, it slips back slightly, so that when it completes one year, it has not precisely completed one cycle. This is called the precession of the equinoxes. After a term of 25,920 years, it returns to the starting point. This 25,920 years is called the Great Year of the celestial cycle, and it precisely fits the Number Code of the Bible. There is no way this display of harmony could be mere coincidence – it is a glorious outpouring of the mind of God!

On the opposite page, I show the names of each of the 12 Zodiac signs, their Hebrew names and the gematria for those names. Would you believe! They total 2592, the total of the celestial cycle.

Virgo	145 = virgin, עלמה
Libra	56 = balances, מאזיה
Scorpio	372 = scorpion, עקרב
Sagittarius	171 = horse-man, אדם-סוס
Capricornus	580 = goat, שעיר
Aquarius	180 = "waters flow from His buckets,"
	מים מדליו, (Numbers 24:7)
Pisces	12 = fish (female fish), דגה
Aries	41 = ram, איל
Taurus	250 = reem, רים
Gemini	441 = twins, תאם
Cancer	261 = "to bind together," אסר
Leo	83 = lion, לבאים (roaring lion)

2592

The complete cycle of the sun through all twelve signs of the Zodiac is **25,920 years.** This harmony of the Number Code with the Constellation Code can only be by divine design. It is a marvelous demonstration of the Master Mathematician! But there's more!

Because the 25,920 years is the complete path of the sun on the circle of the ecliptic, let's show it graphically. It will demonstrate how magnificently this cycle of the sun pictures man's complete experience with sin, and the complete redemption and restoration to a New Beginning. That New Beginning was planned even before Adam sinned, and its story was given to Adam in the starry heavens. And just as surely as much of it has already come to pass, so shall the remainder. We can have confidence because God has promised it.

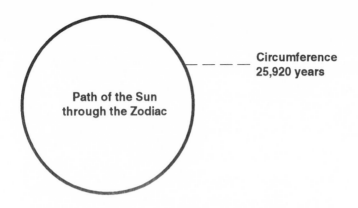

**Circumference
25,920 years**

**Path of the Sun
through the Zodiac**

25920 = The heart of Jerusalem, לב ירושלם,
(Isaiah 40:1, by multiplication)

25920 = As the latter rain, former rain,
כמלקוש יורה, (Hosea 6:3, by multiplication)

These two uses of the number 25,920 are prophetic
of events in earth's great Millennium – the age that brings
to an end the great cycle of man's experience with sin,
and which ushers in the Great 8th Day, the New Begin-
ning. The number 25,920 points to this great cycle by both
the sum of its digits, and the multiplication of its digits:

$$2 + 5 + 9 + 2 + 0 = 18$$
$$2 \times 5 \times 9 \times 2 \times 0 = 180$$

The number 1 represents Beginning
The number 8 represents New Beginning

That Beginning and New Beginning are both accom-

plished through Jesus. **"All things were made by Him and without Him was nothing made,"** (John 1:2). And it is through Him that mankind will be given a New Beginning at the Great 8th Day. This is why He said, **"I am the alpha and the omega."** He was saying, "I am the 1 and the 800" or "I am the Beginner and the New Beginner."

Referring to the path of the sun as shown on the previous page, let's compute its diameter.

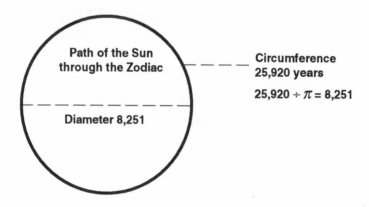

8251 = "In Him was life, and the life was the light of men," (John 1:4), $\varepsilon v \ \alpha v \tau \omega \ \zeta \omega \eta \ \eta v \ \kappa \alpha \iota \ \eta \ \zeta \omega \eta$ $\eta v \ \tau o \ \phi \omega \varsigma \ \tau \omega v \ \alpha v \theta \rho \omega \pi \omega v$

It becomes apparent that the Great Mathematician has interwoven His great design into the most beautiful patters of numerical lace. If we were to divide the diameter of the path of the sun by the circumference of its path, it would produce .318, which is the gematria used in the scriptures for the *sun*.

$8{,}251 \div 25{,}920 = .318$

318 = Sun, $\eta\lambda\iota o\varsigma$

318 = The God of gods and Lord of lords,

אלהי האלהים ואדני האדנים, (Deut. 10:17)

If we were to multiply the Hebrew letters in this title, the product would be 2160 (dropping the rest of the zeros). As the sun passes through each of the 12 signs of the Zodiac, it traverses a period of 2160 years.

Or, simply divide the 8251 by the Golden Proportion twice, and it produces the number of years required for the sun to pass through each sign of the Zodiac.

$8251 \div \phi \div \phi = 2160$

2160 = The God of gods and Lord of lords (same as above but this time by multiplication.)

2160 = Kingdom of the Father, (Matthew 13:43 by addition)

216 = All nations shall serve Him,

כל גוים יעבדוהי, (Psalm 72:11 by addition)

2160 = His dominion, משלו, (Zechariah 9:10, by multiplication)

We can only stand in awe of a Creator whose mathematical display of time and events is so precise! Just as the Psalmist poetically penned, **"The heavens declare the glory of God and the skies proclaim the work of His hands,"** we have been given a display of that plan. and we know with assurance that it will all be fulfilled exactly as planned, and precisely on time.

5
The Coming of Jesus – a Time Line

Many people, who observe the phenomenon of the Bible Codes, ask the question, "Can we predict the future or find time prophecies in the Codes?"

Many have answered "No." However, we must find a reference point in time from which to look back, and call it "past," and look forward and call it "future." If we put our reference point at the time the original texts were written, then all events subsequent to that would be "future," even though from our vantage point here in 1999, it is "past." Now, let's ask the same question again: "Can we predict the future or find time prophecies in the Codes?"

If we can find time prophecies in the Codes that were "future" from the time of the writing of the text, but "past" from our vantage point, then obviously they predicted the future, even though it may not have been seen until it was past.

We have found many such evidences in the Constellation Code. At the time those starry pictures were given to Adam, most of their stories told of events that would be future from that point. And those that are past, from our vantage point, give the unqualified asssurance that those which are yet "future" to us, will just as surely come to pass.

The same can be said for the Symbol Code. Most of

those symbols referred to events "future" from the date of writing. And from our stance, many of them are "past." The logic of this observation needs no expansion.

So, what about the Number Code and the ELS Code. Have we seen past events that were encoded prior to their reality? Yes, many times! One of the most notable examples was the encoding of the name "Jesus" into the prophecy of Isaiah 9:6, as was shown on page 59. We took the plain text which prophesied of the coming of Jesus as a baby, and also as the Prince of Peace and the Ruler of a kingdom that would never end, and used the ELS Code and the Number Code, pulling out every seventh letter, then adding the number equivalents of those letters, producing 888, which is the name Jesus, *Ιησους*. I repeat the process here, the same as was shown on page 59.

Isaiah 9:6

כִּי יֶלֶד יֻלַּד לָנוּ בֵּן נִתַּן לָנוּ וַתְּהִי
400 50 30

הַמִּשְׂרָה עַל שִׁכְמוֹ וַיִּקְרָא שְׁמוֹ
6 6 5

פֶּלֶא יוֹעֵץ אֵל גִּבּוֹר אֲבִי עַד
1 90

שַׂר שָׁלוֹם
300

30 + 50 + 400 + 5 + 6 + 6 + 90 + 1 + 300 = 888
Jesus = 888

This was encoded into the text more than 700 years *before* the birth of the baby who was named Jesus. From our stance, that is "past." Yet, from where we stand, the future implications of this prophecy, containing the name Jesus are yet to happen. We still look forward to His sitting on the throne of David and ruling with justice and righteousness, just like the plain text says. And we know the name of this Ruler, for it was encoded into the prophecy more than 2700 years ago – His name is Jesus!

Recently I was studying in the Psalms, when Psalm 93 captured my attention. It is a short Psalm – only five verses, but it is packed tightly with prophetic significance. It begins, **"The Lord reigns,"** – giving us the time setting for the events described. After giving a brief description of His rulership, it says, **"Your throne is established from then."** From when? The plain text does not give a date, but it can indeed be found in the encoded message. The plain text depicts the beginning of the time when Jesus reigns on David's throne, followed by the tribulation and rise of antichrist, then ends with the conquering of the enemy, and the everlastingness of the Kingdom of righteousness. It is all packed into this short Psalm in symbolic, yet vivid language.

Because the prophecy was so succinct and compact, yet comprehensive, I was curious to see if its gematria, or its ELS would reveal anything.

It should be stated here that during the many years that I have been exploring the gematria of the Bible, I have never found such overwhelming evidence of supernatural design as I find in this Psalm. As I began

adding the number values for the words, I was awe-struck by the quantity of the sacred numbers that were used, and I knew that this short Psalm was telling us something very special. But over and above the preponderance of sacred numbers used in the words, the numbers found in the combination of words, as they appear consecutively in the Masoretic Text, were positively astounding.

The portion of the text which symbolically describes the seven years of tribulation, following the deliverance of the Bride, is described in the plain text as the roaring waves of floods and the mighty breakers of the sea. Putting the words consecutively, as they appear in the text, they read, **"the floods, their roaring waves, more than the voices of waters many, the mighty breakers of the sea."** These words, metaphorically describing the 2520 days of the foretold tribulation period, surprisingly add to 2520. It will be during these 2520 days (7 prophetic years of 360 days each) that the antichrist will rise to power in the revived Roman Empire – thus it was not surprising to find his number within this description of the turbulent waters. **"More than the voices of waters,"** adds to 666. The length of the tribulation has been identified by the gematria of the text, as well as the presence of the antichrist.

But the best was yet to come. Adding the entire description of the events in this Psalm, appears to give the date for their beginning. We have been given the duration of the tribulation – 2520 days – and now we may possibly have been given its starting date.

"Have lifted up the floods their voice; the floods their roaring waves, more than the voices of many waters, the mighty breakers of the sea; is mighty on high Jehovah. Your testimonies are sure very; Your house becomes holiness, O Jehovah." This portion, quoted exactly as it appears in the Masoretic Text, all adds to 6561.

This number probably would not have attracted my attention had I not, just the day before, while playing with my calculator, multiplied the digits in the calendar date of September 11, 1999. It is the day of Rosh Hoshannah – Israel's New Year. It is the date that marks the end of 6000 years from Adam and the beginning of earth's great Millennium. For Israel, it marks the beginning of the year 5760 on the Hebrew calendar. I was curious to find the product of the digits in that pivotal date. They are:

$$9 \times 1 \times 1 \times 1 \times 9 \times 9 \times 9 = 6561$$

I had found the number to be interesting because it is the reverse of 1656 – a number not only important in the gematria of the Bible, but also in the time-line of man's experiences, for it defines the number of years from Adam to the Great Flood. The sum of its digits (1 + 6 + 5 + 6 = 18) shows a Beginning (1) and a New Beginning (8). And that is exactly what this time span of 1656 years experienced: a Beginning with Adam, and a New Beginning with Noah.

This New Beginning with Noah is shown over and

over again in the Number Code. Isaiah spoke prophetically of the time of the tribulation to come upon Israel at the time of their Messiah's return, and called it **"The waters of Noah,"** מי נח, which adds to 108. Jesus used the same illustration when He gave the signs of His return. He said, **"But as the days of Noah were, so shall also the coming of the Son of Man be,"** (Matthew 24:37). The Greek text for **"days of Noah"** is αι ημεραι του Νωε, which adds to 1800. The thought of a New Beginning keeps turning up with the time of Noah.

Thus when I realized the date of September 11, 1999 multiplies to 6561 I wondered if indeed we are dealing with another New Beginning, for not only are the sum of its digits 18, but it has a square root of 81. Could we be looking at the beginning of the new dispensation in which Jesus takes His rightful place as King on David's throne? Conjecture? Yes! But not without reasonable cause.

Enough theorizing for the moment. Let's look at the text. Remember, Hebrew reads from right to left, thus the English translation beneath the Hebrew words also reads from right to left.

Psalm 93

332	332	410	90	26
לבש	לבש גאות	מלך	יהוה	
clothed is with	is He ;with clothed	majesty	;reigns	Jehovah

476	81	613	77	26
תכון-אף		עז התאזר		יהוה
is established	,yea	girded He ;Himself	strength	Jeho-vah

576 is encoded by a skip-2 (backward)

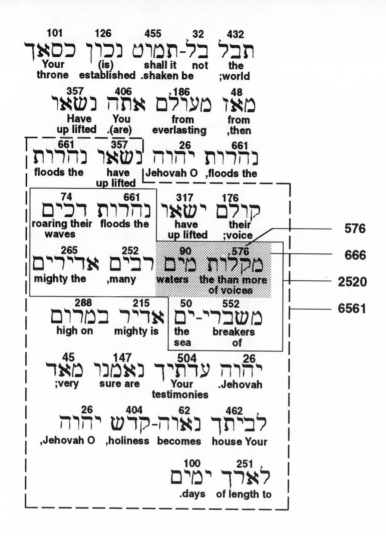

Note that the portion of the text outlined with a broken line bears a total numeric value of 6561, which is the multiplication of the digits in the date 9-11-1999. Within that area is another portion of the text, outlined with a solid line. It has a numeric value of 2520, which is the number of days in the period of tribulation, which will

be cut off when Jesus makes His glorious appearance with His bride, and brings an end to Armageddon. And, notice also, within the 2520 days is a shaded area which adds to 666, showing the presence of the antichrist within those 2520 days. And even the possibility for the date that the 2520 days begin might be shown within that, by the number 576 (the Hebrew year 5760). This number, 576 is also encoded by a skip-2 ELS (backward) in the first verse. Those familiar with the sacred numbers of the scriptures will recognize many more within this remarkable Psalm.

The Hebrew year 5760 begins on September 11, 1999. It marks the completion of 6000 years from Adam, and the probable date that Jesus will officially begin His reign on David's throne. It is logical that the counterfeit Christ will begin his reign the same year. And although we are not told the date of the reign of antichrist, in the plain text, yet the message in the Number Code and ELS Code is quite compelling.

The plain text of Psalm 93 speaks of a mighty flood with roaring waves. The similarity to Noah's day is obvious. The Apostle Peter used this same simile when describing the tribulation of the "day of the Lord." **"…the world that then was, being overflowed with water, perished. But the heavens and earth, which are now, by the same word are kept in store, reserved unto fire against the day of judgment … but be not ignorant of this one thing, that one day is with the Lord as a thousand years …"** Peter was talking about the beginning of the Millennial day and said it would be like the flood of

waters in Noah's day.

By understanding the pictorial language of Psalm 93 we can easily see why it would add to 6561 – the reverse of 1656. In the year 1656 from Adam, Noah and his family were saved by being in the Ark. The Ark pictures our salvation in Jesus Christ. Thus in 6561 (September 11, 1999) we might see the fulfillment – the deliverance of those who are "in Christ," while the nations rage like the roaring waters. Of course, prophecy is best understood after it is fulfilled, so we will have to wait and see.

While on the subject of 6561-1656, it is well to call to our attention a prophecy in Isaiah 14:12, **"How art thou fallen from heaven O Lucifer** (shining star) **son of the morning?"** The Hebrew text adds to 1656. The number suggests that the prophecy is talking about either the time of the Great Flood or the time of the future tribulation. Since the Great Flood was history at the time Isaiah wrote this, I suggest it refers to the coming tribulation; and its placement in the context bears this out. **"And the great dragon was cast out, that old serpent, called the Devil and Satan ... and I heard a loud voice saying in heaven 'Now is come salvation, and strength, and the Kingdom of our God, and the power of His Christ, for the accuser of our brethren is cast down ...'"** (Revelation 12:10-11).

Let's look at Psalm 93 again. It is a most remarkable cryptogram. I suspect that much more is packed into its few words than I have seen here, for I recognize many of the sacred numbers within its text. But I was curious to

apply the ELS principle, and see if it may have more hidden messages. Remembering that I had used a skip-7 sequence when working with Isaiah 9:6 and Isaiah 11:1, I tried a skip-7 sequence with this Psalm. I stand in awe of the results! This short Psalm was masterminded by someone far superior to man. Below I show the Hebrew text (read from right to left), starting with the first letter, using a skip-7 sequence, and ending with the last letter – 26 letters in all. They add to 1680, which is the number for Χριστου, Christ. It is telling us that Christ is the principal character – He plays the principal role – in this endtime drama. He is the victor!

Psalm 93

יהוה מלך גאות לבש לבש
10 3 30

יהוה עז התאזר אף-תכון
70 1

תבל בל-תמוט נכון כסאך
2 9 1

מאז מעולם אתה נשאו
6 300

נהרות יהוה נשאו נהרות
400 1

קולם ישאו נהרות דכים
100 6 20

מקלות מים רבים אדירים
400 40

משברי-ים אדיר במרום
40 1 6

יהוה עֵדֹתֶיךָ נֶאֶמְנוּ מְאֹד
4 50

לְבֵיתְךָ נָאֲוָה-קֹדֶשׁ יהוה
100 10

לְאֹרֶךְ יָמִים
40 30

10 + 3 + 30 + 70 + 1 + 2 + 9 + 1 + 6 + 300 + 400 + 1 + 100 + 6 + 20 +

400 + 40 + 40 + 1 + 6 + 4 + 50 + 10 + 100 + 30 + 40 = **1680**

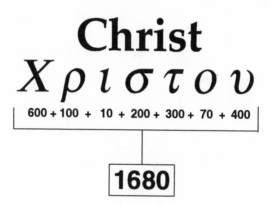

Christ
Χριστου

600 + 100 + 10 + 200 + 300 + 70 + 400

1680

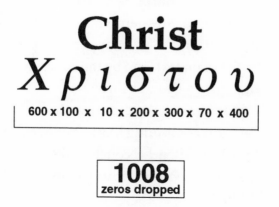

Christ
Χριστου

600 x 100 x 10 x 200 x 300 x 70 x 400

1008
zeros dropped

These two numbers, 1680 and 1008, are tied together in the Golden Rectangle and its inscribed Golden Spiral. A square with sides of 420 (the end-time number) will have a perimeter of 1680. Project its Golden Rectangle, and the Golden Spiral that can be traced on its corners has a length of 1008. They are not random numbers. They reveal the planning of a Master Mathematician!

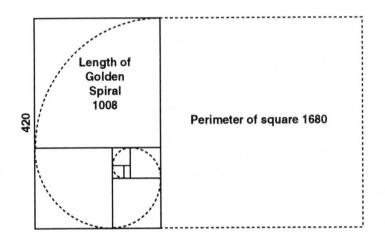

Length of Golden Spiral 1008

420

Perimeter of square 1680

The title "Christ" is the Greek word for "Messiah." It was their promised Messiah who is foretold in this succinct and beautiful Psalm. It appears to portray the time, both by the plain text, and by the codes, when King Messiah will reign on David's throne.

Isaiah prophesied concerning that event. He described the earth as tottering like a drunken man – the time of tribulation. Then he concluded, **"...when the Lord of hosts shall reign in Mount Zion."** Its Hebrew letters add to 1008.

Looking again at this most remarkable Psalm, we find two numbers that make themselves apparent, both in the Number Code and in the ELS Code – they are 252 and 576. In the codes, zeros are often dropped, as is the case here. The Hebrew year 5760, which begins September 11, 1999, is here shown by the number 576. And the 2520 days following that date are shown by the number 252. We saw, in the display of its gematria, that the Hebrew word מקלות adds to 576 and the word רבים adds to 252. These two numbers also appear in the ELS Code, further identifying the date of beginning and length of duration of the tribulation period.

The number 576 can be found twice in verse 1. It is in a skip-20 sequence written forward, and in a skip-2 sequence written backward. The number 252 can be found in verses 1-4 by a skip-47 sequence, written backward.

There are many other obvious occurrences of the sacred numbers in the gematria of this Psalm. Look again at the text and you will see the numbers 26, 81, 432, 32, 126, 101, 48, 186, 176, 74, 576, 252, 288, 504, 462, and 100. They are all part of the sacred number patterns that have to do with the coming of Jesus. Let's look at some of them.

26 = Jehovah, יהוה

2600 = Out of you (Bethlehem) shall He come forth to me to be ruler in Israel, and His goings forth have been from of old, from the days of eternity. (Micah 5:1) ומוצאתיו מקדם מימי עולם ממך לי יצא להיות מושל בישראל

81 = And Jehovah my God shall come (referring to the time of the glorious appearing with His saints) (Zechariah 14:5) ובא יהוה אלהי

432 = The Branch of Jehovah, beautiful and glorious (Isaiah 4:2, both adds and multiplies to 432.)

32 = His glory, כבדו, (Deuteronomy 5:24)

3200 = The Majesty in the heaven (Hebrews 8:1)

32 = Only Son, יחיד

1260 = My Son, ο υιος μου, (II Peter 1:17)

1260 = The Covenant of my peace shall not be removed, (Isaiah 54:10), וברית עלומי לא תמוט

101 = Kingdom, מלוכה

101 = Great is the glory of Jehovah, (Psalm 138:5) גדול כבוד יהוה

48 = The Jubilee, (Leviticus 25:11), יובל

48 = Star (referring to Jesus at His return) (Numbers 24:17) (This both adds and multiplies to 48) כוכב

4800 = The coming of the Son of Man, (Matthew 24:27) η παρουσια του υιου του ανθρωπου

186 = As a tender plant (describing Jesus as a man) (Isaiah 53:2), כיונק

1860 = Firstborn (Jesus) (Romans 8:29), πρωτοτοκον

186 = Golgotha (the place of His death), Γολγοθα

176 = The Lord reigns, (Psalm 47:8), מלך אלהים

1760 = The sceptre shall not depart from Judah nor a lawgiver from between his feet until Shiloh comes, (Genesis 49:10) (Shiloh is Jesus at His return)

740 = Blood of Jesus, (I John 1:7), αιμα Ιησου

740 = Judge of all the earth, (Genesis 18:25)
השפט כל-הארץ

576 = Signs (of His return), מופתים

576 = Trumpet (announcing His return), תקרע

576 = The moon into blood, (sign of His return)
η σεληνη εις αιμα, (Acts 2:20)

576 = The Lord my God and all the saints (the time
of His glorious appearing with His saints)
(Zechariah 14:5), יהוה אלהי כל-קדשים

252 = Mighty, רבים

2880 = Kingdom of heaven, (Matthew 13:47)
βασιλεια των ουρανων

288 = He shall be a priest on His throne, (Zechariah
6:13), והיה כהן על כסאו

504 = They pierced my hands and my feet, (Psalm
22:16), כארי ידי ורגלי

504 = The house of David (Jesus has the key of the
house of David and opens it at His return)
(Amos 9:11), סכת דויד

5040 = The Kingdom of our Lord and His Christ,
(Revelation 11:15), βασιλεια κυριου ημων και
Χριστου αυτου

462 = Until Shiloh comes (Genesis 49:10)
עד כי יבא שילה

100 = My King, (Psalm 2:6) (Referring to Jesus at His
return), מלכי

Indeed, Psalm 93 deserves our attention! It appears
to be giving us the time and events relative to the return

of Jesus and the rise of the ruler who usurps world power. Its display of the sacred numbers is like a red flag saying, "Look at me – I have a message to tell you!" It appears to be giving us the date when the prophetic King will begin His reign on David's throne, as well as the date that His counterfeit will come to power, and the duration of the tribulation.

Does this date – the Hebrew year 5760 – have any validity in the other time prophecies of the Bible? Is it possible to obtain a time-line?

Perhaps the best place to start is with a time-line that has been given to us in the book of Daniel, chapter 9. It was probably from this prophecy that Simeon and Anna were able to know that it was time for the coming of Messiah.

Of Simeon it was said, **"Simeon ... was righteous and devout, looking for the consolation of Israel ... and it had been revealed to him by the Holy Spirit that he would not see death before he had seen the Lord's Christ** (Messiah). **And he came in the Spirit into the temple, and when the parents brought in the child Jesus, to carry out for Him the custom of the Law, then he took Him into his arms, and blessed God, and said, 'Now, Lord, thou dost let thy bondservant depart in peace, according to thy word; for my eyes have seen thy Salvation, which thou hast prepared in the presence of all peoples, a light of revelation to the Gentiles, and the glory of thy people Israel,' "** (Luke 2:25-32).

Of Anna it was said that she was in the temple at

the time Mary and Joseph brought the baby Jesus. She had seen and heard what Simeon had done, **"And at that very moment she came up and began giving thanks to God, and continued to speak of Him to all those who were looking for the redemption of Israel,"** (Luke 2:36-38).

The angel Gabriel (the same angel who brought the announcement of the miraculous begettal to Mary) gave Daniel a time-line to the Messiah. He said, **"Know and understand that from the issuing of a decree to restore and rebuild Jerusalem until Messiah the Prince there will be seven weeks and sixty-two weeks ... then after the sixty-two weeks the Messiah will be cut off ..."** (Daniel 9:25-26).

The counting of the time is historically precise. For a concise explanation of this I will quote from the New American Standard Bible, The New Open Bible Study Edition, page 942:

> The vision of the sixty-nine weeks in 9:25, 26 pin-points the coming of Messiah. The decree of 9:25 took place on March 4, 444 B.C. (Neh. 2:1-8). The sixty-nine weeks of seven years equals 483 years, or 173,880 days (using 360-day prophetic years). This leads to March 29, A.D. 33, the date of the Triumphal Entry. This is checked by noting that 444 B.C. to A.D. 33 is 476 years, and 476 times 365.24219 days per year equals 173,855 days. Adding twenty-five for the difference between March 4 and March 29 gives 173,880 days.

So, the prophecy counts the time precisely to the

Triumphal Entry into Jerusalem which was 4 days before the crucifixion.

Some chronologers say that the decree of Artaxerxes was in the year 445 B.C., and the crucifixion of Jesus was in A.D. 32. This difference of one year is an important element in counting the time accurately. The reason for believing the twentieth year of Artaxerxes was in 445 is because they are counting from the date of Xerxes' death, which was in 465 B.C. Adding 20 years would give the date of 445. However, they fail to take into account a drama that took place following the death (murder) of Xerxes.

An ambitious man named Artabanus killed Xerxes in his bedchamber. Knowing that Xerxes' oldest son and heir to the throne was Darius, Artabanus proceeded to kill him also. This left Artaxerxes as the heir to the throne of Persia. But Artaxerxes was just a young teenager. So Artaxerxes was set up under pretense of being king, but Artabanus was really in power. This arrangement lasted for seven months. Artabanus became unhappy with Artaxerxes, so decided to kill him. But in the scuffle, Artaxerxes succeeded in killing Artabanus.

Soon after this event, another son of Xerxes, Hystaspis, who had been on a journey, heard of the death of the king, and returned to claim his right to the throne. Artaxerxes proceeded to kill him, also. This left Artaxerxes in full possession of the throne of Persia. But the year was no longer 465 B.C., it was now 464. Thus his 20th year, the year of the decree to rebuild the wall of Jerusalem, was indeed 444 B.C., just as is recorded in the

New American Standard Bible.

The concept, based on the 445 B.C. date, places the crucifixion in the year A.D. 32. It should be noted that Nisan 14, the day of the crucifixion, in the year 32 fell on a Monday. Whereas, the correct counting from 444 B.C. brings us to the year A.D. 33 for the crucifixion. Nisan 14 of that year would have been Friday, April 3 on the Julian calendar. There was a lunar eclipse that same day, at 3:00 in the afternoon – the exact time that Jesus died. When the moon rose over Jerusalem that night, it was still in eclipse for 17 minutes.

This date for the crucifixion – Friday, April 3 on the Julian calendar – is confirmed by a document that today resides in the British Museum in London. It is a letter that the Governor Pontius Pilate wrote to the Roman Emporer, in an attempt to explain the reason for having crucified Jesus. At the end of the letter he dates the writing: *"The 5th of the calends of April."* Calends has reference to the first of a month, thus it appears to mean the fifth day of the beginning of April. If so, then this letter was written two days after the crucifixion. Those who attempt to date the crucifixion in A.D. 32 must confront the fact that Nisan 14 of that year was Monday, April 13 – eight days *after* Pilate wrote the letter. Pilate's letter, telling Caesar why the crucifixion which he had just ordered and executed, was necessary, dated April 5, cannot possibly fit the supposed April 13 date for the crucifixion.

This time-line, given by the angel Gabriel to Daniel, provides for us a reference point, from which we can count both forward and backward.

First, let's count backward to the birth of Jesus. If He died in the spring of A.D. 33, His birth would have been in the Autumn of 2 B.C. This date has been contested by many. There have been many dates suggested for His birth, from 1 B.C. all the way back to 6 B.C. Can we find any credible evidence? Yes, I believe we can.

One of the early Christian Fathers, Tertullian, born about A.D. 160 stated that Augustus began to rule 41 years before the birth of Jesus, and died 15 years later. *(Tert. adv. Judaeos c.8)* The date of Augustus' death is recorded as August 19, A.D. 14. This would place the birth of Jesus at 2 B.C. (One year is subtracted because there is no zero year between B.C. and A.D.)

In the same chapter, Tertullian stated that Jesus was born 28 years after the death of Cleopatra. Her death is recorded in history as occurring in 30 B.C.; again placing the birth of Jesus in 2 B.C..

Irenaeus, who was born about a hundred years after Jesus, stated *(iii 25)* that "Our Lord was born about the forty-first year of the reign of Augustus." Since Augustus began his rulership in the autumn of 43 B.C., it would place the birth of Jesus in the autumn of 2 B.C.

Eusebius (c. 264-340 A.D.), who was termed the Father of Church History, wrote: "It was the forty-second year of the reign of Augustus and the twenty-eighth from the subjugation of Egypt on the death of Antony and Cleopatra," *(Eccles. Hist. i 5)*. The 42nd year of Augustus began in the autumn of 2 B.C. and ended in the autumn of 1 B.C. The subjugation of Egypt and its incorporation into the Roman Empire occurred in the autumn of 30

B.C.; therefore, the 28th year from that time extended from the autumn of 3 B.C. to the autumn of 2 B.C. Hence the only possible date for the birth of Jesus that would meet both of these requirements would be the autumn of 2 B.C.

The historian, Josephus, referred to a lunar eclipse that occurred shortly before the death of Herod. Since we know that Herod was alive when Jesus was born, can we place Herod's death by the date of the eclipse?

It has been suggested by some that the lunar eclipse of March 13, 4 B.C. would place the death of Herod prior to that date. However, lunar eclipses are common, often happening two or three times in a single year. Since Josephus, referring to the burning of Matthias by Herod, said, "And on that very night there was an eclipse of the moon," it must have been a noticeable eclipse, and at an hour when people were awake to see it. To find the correct eclipse to which Josephus referred, it would have to comply with the following requirements:

1. An eclipse not less than two months but less than six months prior to a Passover.

2. Be visible in the early part of the night at Jerusalem.

3. Be of sufficient magnitude to be noticeable.

An eclipse that complies perfectly with these requirements occurred on the evening of December 29, 1 B.C., almost exactly three months before Passover. It

was an eclipse of about 7 digits, thus more than half of the orb was obscured. The moon was already in eclipse when it rose over Jerusalem that night, and continued for about two hours, so that even children would have been able to see it before being put to bed.

Since Herod died shortly after the burning of Matthias, but two months before the Passover, his death would have occurred some time in January of 1 B.C. An ancient Jewish scroll, the *Magillah Ta'anith*, written during the lifetime of Jesus, gives the day and month of Herod's death as the 1st of Shebat. This would be January 14 on the Julian calendar.

Information given in the Bible concerning the time of the conception of John the Baptist furnishes another method of determining the date of Jesus' birth. Elizabeth, the cousin of Mary, was the wife of Zacharias, the priest. Zacharias was of the course of Abijah. Luke 1:8-13 states that while Zacharias **"executed the priest's office before God in the order of his course"** he was given the message that Elizabeth would have a son and that they should name him John. In verses 23 and 24 it is recorded, **"And it came to pass that as soon as the days of his ministration were accomplished, he departed to his own house."**

The priests were divided into 24 classes (I Chronicles 24:7-19), and each class officiated in the temple for one week. The courses of the priests changed duty with the change of the week, *i.e.*, from the end of the Sabbath at sundown until the next Sabbath. Both the Talmud and the historian, Josephus, state that the temple was

destroyed by Titus on August 5, A.D. 70, and that the first course of priests had just taken office. The previous evening was the Sabbath. The course of Abijah was the 8th course, thus, figuring backward we are able to determine that Zacharias ended his course and came off duty on July 13, 3 B.C., and returned home to Elizabeth. The conception of John occurred that weekend (13th-14th) and the birth of John would take place 280 days later, namely, April 19th-20th of 2 B.C., precisely at the Passover of that year.

Elizabeth hid herself five months, and at the beginning of her 6th month the angel Gabriel appeared to Mary, telling her of Elizabeth's condition. At the same time Gabriel told Mary that she, too, would conceive and bear a son who would be called Jesus. Upon hearing this, Mary went **"with haste"** from Nazareth to Ein Karim to visit Elizabeth, who was then in the first week of her 6th month. The time was the 4th week of December, 3 B.C. The 23rd of December of that year, by the Julian calendar was precisely the winter solstice. If this were the date of the conception of Jesus, 280 days later would place the date of His birth at September 29, 2 B.C., *i.e.*, the first day of Tishri, the day of the Feast of Trumpets – the Hebrew New Year, Rosh Hoshanah.

Luke 3:1 states that John the Baptist began his ministry in the 15th year of Tiberius Caesar. According to the Law of Moses, an Israelite was considered of age for the ministry at 30 (Numbers 4:3). Augustus had died on August 19, A.D. 14; thus that year became the accession year of Tiberius, even though he had been involved in

and associated with the Roman rulership before Augustus died. If John the Baptist had been born April 19-20, 2 B.C., his 30th birthday would be April 19-20, A.D. 29, or the 15th year of Tiberius. Thus the 2 B.C. date for the birth of John is confirmed by the Biblical record. John was 5 $1/3$ months older than Jesus, making the birth of Jesus to be near the end of September of that same year.

We know that Jesus had just turned 30 years old at His baptism (Luke 3:23). Thus if He had been born in the autumn of 2 B.C. the baptism would have been in the autumn of A.D. 29. We have the scriptural testimony that Jesus observed 4 Passovers during His ministry (John 2:13; 5:1; 6:4; 13:1). The observance of 4 Passovers would bring Him to the spring of A.D. 33. The day of His death was on that 4th Passover, the 14th of Nisan. It was the day of full moon, and it was Friday, April 3, of the year A.D. 33.

Thus the years of Jesus' birth and death can indeed be determined by the historical, scriptural, and astronomical records.

I apologize if I have burdened the reader with these details, but I feel it is extremely important to identify the accurate dates for His birth and death, because those two events are pivotal points upon which a time-line must rest.

Counting backward 69 prophetic weeks from the year of His death brings us to the year in which Artaxerxes gave Nehemiah the decree to return and rebuild the walls of Jerusalem – the year 444 B.C.

Counting forward from the date of Jesus' birth (1st

Tishri of 2 B.C.) 2000 years brings us to 1st Tishri of A.D. 1999, which, on our Gregorian calendar is September 11. (Remember, when counting years from B.C. to A.D. there is no zero year.) In this calculation we are not dealing with "prophetic time," we are stating it in actual calendar years of 365.242 days each.

Some have raised an objection to this simple calculation by suggesting that the change from the Julian calendar to the Gregorian calendar which we use today, has mixed up the years so that we do not have an accurate count. As far as I am aware, the only time that was lost in the change of calendars was eleven days, which they simply dropped to make the calendar agree with the season. I do not think the dropping of eleven days changes the date of Rosh Hoshanah, which is determined by the appearance of the first thin sliver of the New Moon. In the year 1999, this first appearance of the New Moon is after 6:00 p.m. September 10 to 6:00 p.m. on the 11th.

But why would we think that 2000 years from Jesus' birth would be an important date?

There are several reasons. One observation is that the date marks 3000 years from the time King David was anointed king over all Israel, and 6000 years from Adam.

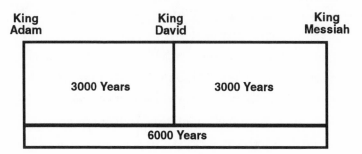

In Exodus 31 God gave to Moses the law of the Sabbath, in which He equated the Sabbath with the seventh day, following the six days of creation – the "day" in which God rested from His works of creation. God said, **"It is a *sign* forever between Me and between the sons of Israel; for in *six days* Jehovah made the heavens and the earth, and on the seventh day He rested and was refreshed."** Encoded into that instruction to Moses was the year 5760, which would bring mankind to the end of 6000 years from Adam.

Those **"six days"** in the Number Code multiply to 5760 – the Hebrew year which marks the end of 6000 years and the beginning of the great Sabbath, the Millennium.

days

ימים

40x10x40x10

six

ששת

400x300x300 = **5760**

(dropping the rest
of the zeros)

It is quite remarkable that the plain text gives **"six days"** while the hidden text clearly gives the year 5760. Do the six days really end with the Hebrew year 5760? Let's look just a bit further into the encoding of this text. The verse reads, **"In six days Jehovah made the heavens and the earth."** If we assigned the number equivalents for each of the Hebrew letters in this statement, they would add exactly to 3000. They are not random num-

bers. I believe they were encoded into the text for a grand purpose!

It was the belief of the ancient writers, and it is the belief today, that 6000 years from Adam would usher in the great Millennium, thus making the "day" in which God rested from His works of creation to be, in fact, a period of 7000 years, to be followed by the Great 8th Day, the Grand Octave of Eternity. It was also the belief of the ancients that there would be 3000 years from King Adam to King David, and another 3000 years to King Messiah.

We have the historical record that the second half of this 6000 year period has been right on time. David was anointed king over all Israel in the year 1002 B.C. Add to this date 1000 years and it will bring us to the date of the birth of Jesus, in 2 B.C. Add another 2000 years and it will bring us to September 11, 1999, which is the beginning of the Hebrew year 5760.

The precision that we find in that second half of the 6000 years, suggests that there was also precision in the first half. The same Magnificent Timekeeper is Lord of both.

The counting of the time backward from the anointing of David is not so simple. We are given a time span in I Kings 6:1 of 480 years (actually 479 years and two months) back from the 4th year of Solomon to the Exodus. Then we are given a time span in Galatians 3:17 of 430 years back from the Exodus to the Covenant with Abraham. And from the genealogies in the book of Genesis we can count the time from the Covenant back to the great flood – a span of 437 years. Then from the flood

back to Adam the genealogies give 1656 years. But when we get all the way back to Adam we must, of necessity, make a very important observation. Adam was created on the sixth day, not on the seventh. But our counting of time has been for the seventh, and we have counted 2966 years from Adam to the anointing of King David.

Adam was created in perfection – in the image and likeness of God – sometime during the sixth day. As long as he was in perfection he was in "eternity," for had he not sinned he would have lived forever. In "eternity" there is no need to count age. However, after living in "eternity" for an unstated length of time, he sinned. The counting of his "age" began, because they were the years of his dying. From the point in time at which he sinned, the death process was working in him, and his years of dying began to count. Understanding this important principle, the next logical question is, "How long was Adam in perfection before he sinned?" The historical record does not say. However, the information can be obtained.

When counting the time backward from the anointing of David (1002 B.C.) to Adam, the total years comes to 2966. When counting the years forward from the *death* of David to King Messiah, we also get 2966 years. The mid-point of this calculation becomes the 33 $1/2$ years in which David ruled over all Israel. This suggests that Adam may have lived in the Garden of Eden in perfection for 33 $1/2$ years.

Jesus is called the Second Adam, because He was a perfect man, and gave His life as a substitute for the for-

feited life of Adam. If Adam had lived 33 $^1/_2$ years in perfection, then he sinned, the death sentence would have been placed upon him at the point of the sin. Thus the Second Adam, the exact counterpart of the first Adam, lived in perfection for 33 $^1/_2$ years, then gave His life to pay for the sin which Adam had committed. God's times are precise.

The Bible calls this a "ransom." The Greek term used for this transaction is $αντιλυτρον$ which means *a price to correspond*, or *a redemption price*. Jesus' sacrifice was an exact $αντιλυτρον$ in every way, even to the number of years that He lived as a perfect man – 33 $^1/_2$.

Thus, when counting the years back from King David to King Adam – to Adam as he was created in perfection – we must add 33 $^1/_2$ years to the 2966, which takes us into the 3000th year. (The 130 years given in Genesis to the birth of Seth are counting the years of Adam's dying, from the time he sinned.) This gives an added feature to the over-all time-line (shown on next page).

What evidence, or authority do we have upon which to base the concept of 6000 years from King Adam to King Messiah?

In addition to the scriptural evidence stated above, that six days man would work, followed by a Sabbath, let's look at the record of some of the ancient writers. Although these writings have not been included in the canon of scripture, nevertheless, they have great value as historical records. Even if they were not divinely inspired (and some of them may have been), their testi-

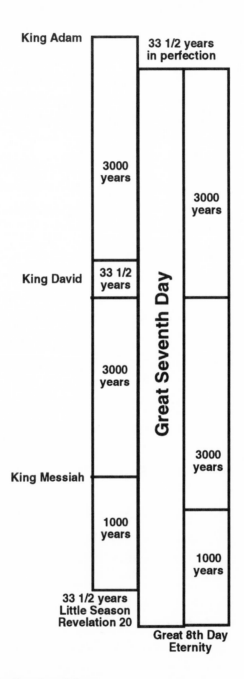

mony reflects the knowledge of the one doing the writing.

The book of *II Esdras* was written sometime during the first century before Christ, with its first and last chapters added during the first century after Christ. Esdras (a pseudo name) claimed that the angel Uriel told him, in a vision, that from Adam to King David was 3000 years. Whether the angel Uriel actually told him this, or whether Esdras was simply writing a good story, is not necessary for us to determine – it still reflects the knowledge of the writer at that time.

Barnabas, who was the traveling companion of Paul, wrote concerning the six days (6000 years) followed by the Sabbath (Millennium). His letter dates back to the first century after Christ. He said:

> Even in the beginning of Creation he makes mention of the Sabbath. And God made in six days the works of his hands; and he rested on the seventh day, and sanctified it. Consider, my children, what that signifies – he finished them in six days. The meaning of it is this: that in six thousand years shall all things be accomplished. Then he shall gloriously rest in that seventh day ... when resting from all things I shall begin the eighth day, that is, the beginning of the other world.

Barnabas was describing the 6000 years followed by a 7th, just as there were 6 divisions of creation, followed by a 7th. All of which is followed by the great 8th day, which is a New Beginning.

This analogy by Barnabas is also spoken of in a book

called *The Secrets of Enoch.* This book was supposedly written about Enoch. Its authenticity, and its value can only be subjective to the scrutiny of the reader. However, one thing is for certain: if it was not divinely inspired, then it reflected the knowledge and belief of the writer. And that has historical value. Here is what we find in *The Secrets of Enoch.*

> And I blessed the seventh day, which is the Sabbath, on which he rested from all his works. And I appointed the eighth day also; that the eighth day should be the first-created after my work, and that the first seven revolve in the form of the seventh thousand, and that the beginning of the eighth thousand there should be a time of not-counting – endless.

What the above writer is actually saying is that 7000 years became the 7th of the creative six. This makes the 8th day the 8th for man's experience, but also the 8th on God's great work week. It is interesting that in the number symbols of the Bible, the number 8 always represents a New Beginning. In fact the letter-numbers for the Hebrew word *beginning*, אֹר, add to 8. The New Beginning for mankind is made possible through Jesus – and the letter numbers of His name, *Ιησους* add to 888. When He is king on David's throne, during the 7th thousand year span, it is said of Him, **"He must reign until He has put all enemies under His feet."** The numeric value of that promise is 8888. The end of that time, following the putting of all enemies under His feet, will be the beginning of the Great 8th Day – the New Beginning.

In the Babylonian Talmud (200-400 A.D.) there is a large section in which several prominent Rabbis express their opinion on the time of the coming of Messiah. Rabbi Kattina wrote:

> The world endures 6000 years and one thousand it shall be laid waste, that is, the enemies of God shall be laid waste, whereof it is said, "The Lord alone shall be exalted in that day." As out of seven years every seventh is a year of remission, so out of the seven thousand years of the world, the seventh millennium shall be the 1000 years of remission, that God alone may be exalted in that day."

From the above ancient writers, it appears to have been the belief that man's current experience covers a span of 6000 years, followed by a Sabbath, all of which is a Sabbath on God's great work week, to be followed by the New Beginning – the Great 8th Day.

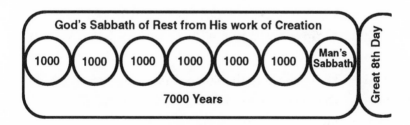

It appears that this span of 7000 years is offset from the 7000 years of man's experience by the short span of 33 $^1/_2$ years, allowing for Adam's time of perfection in the Garden of Eden at the beginning, and for the Little Season of Satan at the end.

By including the 33 $^1/_2$ years of Adam's perfection before he sinned, the time span of 6000 years bring us to September 11, 1999, which is New Year's Day for the Hebrew year 5760. If that is the date for King Messiah to take His place on David's throne, then the beautiful Golden Proportion again comes into play.

From the day Adam sinned to the time when David was anointed King of God's typical kingdom was a span of 2966 years. From David's death (the end of David's reign) to September 11, 1999 is also a span of 2966 years.

Adam sinned	David's typical kingdom		The antitypical David takes the throne
2966 years	33 $^1/_2$ years	2966 years	

2966 divided by the Golden Proportion becomes 4800. (2966 ÷ .618034 = 4800) In the Number Code, the number 48 appears to relate to the time of Jesus' return.

4800 = The coming of the Son of Man, (Matthew 24:27)
480 = The Breaker has come up (Jesus), (Micah 2:13)
48 = The Star (Jesus, (Numbers 24:17)
48 = The Jubilee

Using this same mathematical principle we find that the time span from the birth of Jesus to His becoming the antitypical King on David's throne also produces an interesting number.

| Birth of Jesus
1st Tishri, 2 B.C. | Jesus takes the
throne of David
1st Tishri, A.D. 1999 |

```
┌─────────────────────────────────────────┐
│                                          │
│              2000 years                  │
│                                          │
└─────────────────────────────────────────┘
```

$$2000 \times .618034 = 1236$$

1236 = God with us (Immanuel), (Matthew 1:23)

1236 = The Chief Shepherd, (Jesus at His return)
$\alpha\rho\chi\iota\pi o\iota\mu\epsilon\nu o\varsigma$, (I Peter 5:4)

1236 = A Root out of dry ground (Jesus, coming forth
from the line of David to reign on David's
throne) שרש מארץ ציה, (Isaiah 53:2)

The Golden Proportion is called the Divine Proportion because it is said to be the most pleasing proportion to human perception. It is also the growth principle of all creation. It is used in the Number Code of the Bible as the number 618 (the Golden Proportion is .618 but decimals are not shown in gematria).

In the book of Malachi (3:2) the question is asked, **"Who can endure the day of His coming? Who can stand at His appearing?"** The Hebrew word for **"His appearing"** is הראותו, and it adds to 618, the Golden Proportion. It is used often in scriptures that are prophetic of Jesus and His coming Millennial Kingdom. The prophet Zechariah, when speaking of Jesus' return said, **"The Lord shall be king over all the earth."** The numeric value of that statement is 618.

One of the names that will be His at His return is Shiloh. It was the name that Jacob used when he gave a blessing to his son Judah. Shiloh means the *"peacemaker"* or *"the one who brings rest."* Before Jacob pronounced the blessings on each of his twelve sons, he gathered them together and said, **"Gather yourselves together, that I may tell you that which shall befall you in the last days."** He was talking eschatology. He said these things would come in the **"last days."**

When it came Judah's turn to receive the blessing, Jacob said, **"The sceptre shall not depart from Judah, nor a lawgiver from between his feet, until Shiloh come; and unto him shall the gathering of the people be."** The prophecy is talking about rulership – kingship. The symbol of the sceptre means having the right to rule. The first king to come from the line of Judah was King David. His kingdom was a type of the reign of King Messiah – the Lion of the Tribe of Judah – who is of the lineage of Judah through David. But the amazing thing is that this prophecy gives us a time-line for that rulership, by the Number Code. It was skillfully and magnificently encoded into the text with the use of the Golden Proportion. It not only tells of the 1000 years from King David to the birth of Jesus, and the 3000 years from King David to King Messiah (Shiloh), but as an added feature, it tells us of the 4000 years from King David to the full completion of the Millennial Kingdom and the beginning of the Great 8th Day, God's Grand Octave.

Below is the prophecy as it appears in the Masoretic Text. Remember, Hebrew reads from right to left, so it is

necessary when reading word-for-word, to also read the English from right to left. (This was shown on page 22, but I will repeat it here.)

לאיסור שבט
= 618
שבט — The sceptre — 311
לאיסור — shall not depart — 307

מיהודה ומחקק מבין רגליו
= 2472
רגליו — his feet — 249
מבין — from between — 102
ומחקק — the nor lawmaker — 254
מיהודה — from Judah — 70

עד כייבא שילה
= 1854
שילה — Shiloh — 345
כייבא — comes — 43
עד — until — 74

ולו יקהת עמים
עמים — the peoples — 160
יקהת — the obedience of — 515
ולו — and to him — 42

$$618 \div \phi = 1000$$
$$1236 \div \phi = 2000$$
$$1854 \div \phi = 3000$$
$$2472 \div \phi = 4000$$

The blessing that Jacob placed upon the head of his son Judah reaches all the way down through time. It is the story of Kingship. The numbers that were encoded into the text give us the time-line for that Kingship.

618 divided by the Golden Proportion equals 1000, and there are exactly 1000 years from the time King David began to reign over all Israel to the birth of Jesus, the

"Son of David" – born to be a king.

1854 divided by the Golden Proportion equals 3000, and there are 3000 years from King David to the time when King Messiah takes His great power and begins His reign.

2472 divided by the Golden Proportion equals 4000, and there are 4000 years from the first king of Judah's line to the completed work of Shiloh.

The amazing Golden Proportion has been encoded into the time-line that has been given to us by the prophet Daniel. It is in his famous Messiah count-down. The prophecy enumerates six things that would happen during the alloted 70 weeks. They are:

1. to finish transgression
2. to put an end to sin
3. to atone for wickedness
4. to bring in everlasting righteousness
5. to seal up vision and prophecy
6. to anoint the Most Holy

The first three were accomplished in A.D. 33 when Jesus died. The remaining three will be accomplished at, and because of, His return, at the fulfilling of the final "week." By adding the gematria of the Hebrew letters, the last two items define the Golden Proportion: **"to seal up vision and prophecy"** adds to 618, and **"to anoint the Most Holy"** adds to twice 618, or 1236. Thus it appears that the Golden Proportion has been intricately interwoven into the fabric of His return by an intelligence

far surpassing that of man.

The Golden Proportion and its accompanying Golden Spiral can be shown graphically, and when we draw it, we become startlingly aware of its beauty and significance regarding the time of the return of Jesus as King Messiah.

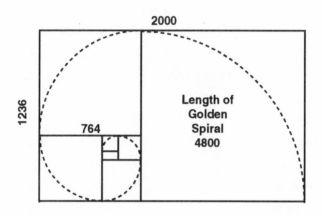

The time-line from the birth of Jesus to His return has been shown to be a span of 2000 years. Thus the long side of the Golden Rectangle is 2000 years. In Revelation 22:12, after a lengthy and magnificent vision given to John regarding the end times and the glorious Kingdom, John was given the comforting and reassuring promise: **"Behold, I come quickly, and my reward is with me."** Encoded into the gematria of the text is the time span of 2000 years. If we add the number equivalents from the Greek text for **"and my reward is with me,"** they will total precisely 2000.

The short side of the above Golden Rectangle gives the name Immanuel, "God with us," which, in the Greek

text, adds to 1236. He is further identified by His title of Chief Shepherd. For when the Apostle Peter was speaking of Jesus' return, he said, **"When the Chief Shepherd appears, you will receive a crown of glory that will never fade away."** His use of the title "Chief Shepherd," which adds to 1236, confirms that Immanuel and the Chief Shepherd are indeed one and the same. Isaiah verified this when he referred to Jesus as **"A Root out of dry ground,"** (Isaiah 53:2), which , in the Hebrew text, also adds to 1236. He was prophesying that Jesus would be the living heir to the throne of David.

This double of the Golden Proportion, which is the short side of the above Golden Rectangle, 1236, was used again by the angel who spoke to Daniel. After giving Daniel the prophecy concerning the time when Michael would stand up, which would be immediately followed by the time of tribulation, one of the angels asked, **"How long until the end of these wonders?"** Encoded into the question is a hint of the answer; for the phrase, **"until the end of these wonders,"** in the Hebrew text, adds to 1236. But the angel who spoke the answer proceded to say that there would be **"time, times and a half time."** He was referring to half of the final tribulation week.

And even that final tribulation week was included in the above Golden Rectangle. It is shown by the number 764, which is the number equivalent in the Greek text for the **"tribulation"** which accompanies the return of Jesus.

But the most beautiful of all is the Golden Spiral that can be traced on the geometry of this remarkable

Golden Rectangle. It has a length of 4800.

Jesus had been answering the questions of His disciples who had inquired regarding the time of His return. He gave them many signs, then He said, **"For as the lightning cometh out of the east, and shineth even unto the west, so shall the coming of the Son of Man be."** The addition of the number values for **"the coming of the Son of Man"** is exactly 4800. It was no coincidence. It was the confirming of the time between the reign of King David and the coming of King Messiah, for 4800 multiplied by the Golden Proportion produces 2966, which is the exact number of years between the end of David's reign and the beginning of the reign of King Messiah, bringing us to the beginning of the Hebrew year 5760.

Do we have any evidence that the tribulation "week" will begin with that date, or is it conjecture?

Michael Drosnin, author of the best seller, *The Bible Code*, found something regarding the date for Armageddon, which ends the tribulation week. In his search for ELS Code information, he observed[1] that the Hebrew date 5766 crossed the words "World War" and "Atomic Holocaust" in the first few verses of the *Mezuzah*.

The *Mezuzah* is a 170-word scroll, within the text of the Torah (found in Deuteronomy), which was extremely sacred to every Israelite. They were commanded to nail it on the doorposts of their houses, and to wear it around their necks or between their eyes. They were commanded

1 Michael Drosnin, *The Bible Code*, Simon & Schuster, New York, 1997, p. 126.

to memorize it and talk about it on all occasions. It was to be uppermost in their awareness. Within its admonitions, Israel was commanded to hear **"these words"** and **"to love the Lord your God."** These were the key concepts of the whole text. Realizing this, I was curious about the numeric value of those two commands. To my surprise, I found they are the two numbers which identify the tribulation week, 252 and 576, (5760 being the date for its beginning, and 2520 days being its duration).

252 = These words, דברי אלה
576 = To love the Lord your God,
לאהבה את-יהוה אלהיכם

Thus, if we add 2520 days to the date 5760, it brings us to late in the year 5766. Drosnin said he found both dates (5760 and 5766) encoded in the text, crossed by the words "World War" and "Atomic Holocaust." I've checked his work, and it is the Hebrew letters ה(5), ת(400), ש(300), ס(60), ו(6). It can be read either as 5760 or, by adding the final 6, can be read as 5766. He observed that this date was encoded twice within the first few verses of the Mezuzah. Because the final 6 is indeed there, I suspect that the year 5766 is the one intended because the words "World War" and "Atomic Holocaust" appear with it, and those words seem appropriately to describe Armageddon.

I was curious to see if this number, 5766, was encoded elsewhere in prophecies whose plain text also described the same event. It was exciting to find it in

Isaiah 31:9 - 32:1. These two verses connect chronologically. They tell of the destruction of Isarel's enemies in the final battle, and the beginning of the reign of righteousness. And encoded within these two verses, by a skip-13 sequence, is the date 5766. **"And his stronghold shall pass away from fear, and his chiefs shall tremble at the banner, declares Jehovah, whose fire is in Zion, and His furnace in Jerusalem. Behold, a King shall reign in righteousness and princes shall rule in judgment."**

This method of writing the date 5766 is the correct method for a number more than one thousand – and it would be pronounced *"five thousand seven hundred and sixty six."* I wondered what I might find if I pronounced it the way we generally do – *"fifty seven sixty six."* This could be written as ‫נ‬(50), ‫ז‬(7), ‫ס‬(60), ‫ו‬(6) – however it would of course read from right to left instead of the way I have it here. I was amazed to find it in Isaiah 52 in a plain text which describes the saving of Jerusalem from their enemies by the hand of God, and the setting of up the Kingdom of God. It clearly describes the events which bring to an end the tribulation week. Here is the plain text as it is written in the New International Version:

"How beautiful on the mountains are the feet of those who bring good news, who proclaim peace, who bring good tidings, who proclaim salvation, who say to Zion, 'Your God reigns!' Listen! Your watchmen lift up their voices; together they shout for joy. When the Lord returns to Zion, they will see it with their own eyes. Burst into songs of joy together, you ruins of

Jerusalem, for the Lord has comforted his people, he has redeemed Jerusalem. The Lord will lay bare his holy arm in the sight of all nations, and all the ends of the earth will see the salvation of our God."

Encoded within this exciting prophecy, by a skip-28 (4x7) sequence is the date 5766 (pronounced as we usually do – fifty seven sixty six). It describes the ending of the tribulation and the comforting of Jerusalem.

Within this same text, has been encoded the name of Jesus by its Hebrew spelling, ישוע, five times, and it finishes with the name of Jesus, 888, in the Number Code. The Magnificent Encoder went to great lengths to give us the message that this great event will be the work of Jesus at His return! **"The salvation of our God"** has a numeric value of 888.

If the time for the end of the tribulation is the Hebrew year 5766, it would be some time between Rosh Hoshanah of 2005 and Rosh Hoshanah of 2006. Counting backward 2520 days, or 7 prophetic years of 360 days each, brings us to sometime between Rosh Hoshanah of 1999 and Rosh Hoshanah of 2000.

Referring to that period of seven prophetic years, the prophet Jeremiah (33:15, 16) made a most interesting statement:

"In those days and at that time I will make a righteous Branch sprout from David's line; he will do what is just and right in the land. In those days Judah will be saved and Jerusalem will live in safety. This is the name by which it will be called: The Lord Our Righteousness."

By adding the numeric equivalents for every Hebrew letter in this text, we find the total to be 6005. Could it be a hidden message? Could it be telling us that when 6005 years from Adam have been accomplished, that Jerusalem will be saved and the long-promised Kingdom will at that time become a reality? The possibility is indeed exciting!

I have spoken much about the 6000 years from Adam and the 2000 years from the birth of Jesus bringing us to the date of Rosh Hoshanah in 1999, the beginning of the Hebrew year 5760. And there is a prophecy in the book of Hosea that has been used by many students of prophecy to suggest a period of 2000 years until Jesus' return. It proves to be a most interesting and beautiful prophecy.

The book of Hosea is generally prophetic of the casting off of Israel (both Israel and Judah) because of their unfaithfulness; and the eventual re-marriage of God to Israel at a time when they will indeed become faithful. This is an over-simplification of an involved subject, but sufficient for our purposes here. Let me quote the prophecy from Hosea 6:1-3:

"Come, let us return to Jehovah, for He has torn, and He will heal us. He has stricken, and He will bind us up. After two days He will bring us to life. In the third day He will raise us up, and we shall live before Him. Then we shall know, we who follow on to know Jehovah, His going forth is established as the dawn; and He shall come to us as the rain, as the latter and former rain to the earth."

First, let's look at the concept of **"after two days"** and **"on the third day."** Is this a time prophecy? Many have believed that it is, and I concur. We need to look at the time from which they were cast off, to the time when they will be re-established. And we need to be aware that if this is a time prophecy, then it must be computed by prophetic time – 360 days per year.

Just a few days before Jesus was crucified, he spoke the proclamation of rejection on Jerusalem and its people. He said, **"O Jerusalem, Jerusalem, thou that killest the prophets, and stonest them which are sent unto thee, how often would I have gathered thy children together, even as a hen gathereth her chickens under her wings, and ye would not! Behold, your house is left unto you desolate. For I say unto you, Ye shall not see me henceforth, till ye shall say, Blessed is he that cometh in the name of the Lord."** (Matthew 23:37-39). It was at that time, in the year A.D. 33, that Israel was cast off from the relationship that they had with God, which Hosea pictured as a wife. The "divorce" became final when, on the cross, Jesus said, "It is finished."

But Hosea had prophesied that this breach of relationship would be healed, **"after two days"** and **"on the third day."** And when Jesus said that their house was left to them "desolate" He followed that by assuring them that they would indeed see Him again, when they would then say **"Blessed is he that cometh in the name of the Lord."**

It remains, then, to compute the two days from A.D. 33, and it should bring us to the time when they would

recognize Him and joyfully accept Him.

Considering these as "thousand-year days," we must also consider those years as being 360 days each. Two thousand years of 360 days each becomes 720,000 days. Divide this by 365.242 and it gives us a period of 1971.30 years. If we begin counting this length of time from the spring of A.D. 33 it brings us to the spring of the year 2005. The prophecy specified *"after* **two days"** and *"on* **the third day."** Thus the time fits precisely with the above concepts regarding the ending of the tribulation week and the comforting of Jerusalem beginning between Rosh Hoshanah of 2005 and Rosh Hoshanah of 2006. And those in Jerusalem who witness the destruction of their enemies by the Glorious Appearing of the returned Jesus, will indeed say **"Blessed is He that cometh in the name of the Lord."**

It is exciting to realize that the prophecy of the coming of Jesus, the one who would be called Immanuel – God with us – gives us the two numbers that the Israelites were told to bind about their necks, nail to the doorposts of their houses, and talk about on all occasions. They are the numbers 5760 and 2520. Isaiah said, **"Behold, a virgin shall be with child and shall bring forth a son; and she shall call His name Immanuel."**

5760 = she shall call His name (by multiplication)
2520 = Immanuel (by multiplication)

One of the important things that I was taught, as a small child, was that "prophecy is best understood after it is fulfilled." I had good mentors. The concepts of this book are only my perception of prophecy. The good news is that we do not have long to wait to find out whether they are true or false. Because many predictions of the past have failed to materialize as suggested, many authors of eschatology today are shy of putting their beliefs out there where all can see them fail. I run the same risk, but that's okay. I feel it is important to let the Word of God speak, and if I have interpreted incorrectly, the Word of God remains true, for which I praise Him!

I have not suggested a specific date for the deliverance of the "church" – the believers, the followers of Jesus. However, in the Symbol Code the building and completion of the Second Temple was symbolic and prophetic of the building and completion of the Heavenly Temple – the "church." In Ezra 6:15 we are told, regarding the Second Temple, **"And this house was finished on the third day."** The Hebrew words **"third day,"** תלתה יום, multiply to 5760. The Hebrew year 5760 begins the "third day" from the first coming of Jesus. The possibilities are exciting!

Appendix I
Gematria Methods

In chapter 2 we saw how the Number Code works. However, the method I showed was the common method known as *Ragil* Gematria. It is the substituting of a number for each letter of the alphabet. There are many other methods of gematria. I have not researched most of them, but for over thirty years have confined my research to the *Ragil* method, plus some multiplication which uses the principle of the *Katan* method. This method reduces all numbers above 9 to one digit by simply dropping the zeros. I have used that method when multiplying because it fits on the calculator, and the zeros would be dropped at the end of the calculation anyway.

There is another method known as *Klala*, which adds the squares of the numbers for each letter. This produces some interesting results which we shall see.

There are also several methods of letter substitution. The common method is known as *Atbash.* It simply substitutes the last letter of the alphabet for the first, and so on down through the alphabet. Its code would be ת=א, ל=כ, מ=י, נ=ט, ס=ח, ע=ז, פ=ו, צ=ה, ק=ד, ר=ג, ש=ב, א=ת, ב=ש, ג=ר, ד=ק, ה=צ, ו=פ, ז=ע, ח=ס, ט=נ, ס=ח, ע=ז, מ=י. This method was used by Jeremiah (Jer. 25:26 and 51:41) when prophesying about the king of Babylon – he called him Sheshach, which is an *Atbash* code for Babylon, בבל, making it ששך.

When working with the Sacred Name with these codes we get some astonishing results. The name that we generally call Jehovah, is sometimes called the Tetragrammaton, or the unpronounceable name. Its Hebrew letters are יהוה (YHVH). In regular *Ragil* Gematria it bears the number 26. However, when we multiply those letters, the name becomes 1500. This is the number for "light" in the Greek text. It is an appropriate number for the Almighty, because we are told that "God is light."

When we use the *Klala* method, and add the squares of the value for each letter, the total becomes 186. It still refers to light, which has a speed of 186,000 miles per second (rounded number).

And if we use the *Atbash* code, and multiply the letters, we get 25920, which is the number of years it takes the sun to pass through all twelve sections of the Zodiac. It still has reference to light. It does not appear to be a coincidence.

These methods of decoding the name of Jehovah are shown below:

Ragil Gematria: יהוה (5+6+5+10) = **26**

Ragil multiplication: יהוה (1x5x6x5) = **1500**

Klala method: יהוה (100+25+36+25) = **186**

Atbash method (multiplication): מצפץ
(90x80x90x40) = **25920** (dropping rest of zeros)

David Baron, *The Ancient Scriptures for the Modern Jew,*
Yanetz, Ltd., Jerusalem, Israel
— *Types, Psalms, and Prophecies,* Yanetz, Ltd.,
Jerusalem, Israel, 1978

Frederick Bligh Bond and Thomas Simcox Lea, *Gematria,*
RILKO Books, London, England, 1977

E. W. Bullinger, *Number in Scripture,* Kregel Publications
Grand Rapids, MI 1967
— *The Witness of the Stars,* Kregel Publications,
Grand Rapids, MI 1967

E. Raymond Capt, *The Glory of the Stars,* Artisan Sales,
Thousand Oaks, CA 1976

Michael Drosnin, *The Bible Code,* Simon & Schuster,
New York, NY 1997

Bonnie Gaunt, *Jesus Christ: the Number of His Name,*
Bonnie Gaunt, Jackson, MI 1998
— *Beginnings: the Sacred Design,* Bonnie Gaunt,
Jackson, MI 1995
— *Stonehenge and the Great Pyramid: Window
on the Universe,* Bonnie Gaunt, Jackson, MI 1993
— *The Stones Cry Out,* Bonnie Gaunt, Jackson,
MI 1991
— *The Magnificent Numbers of the Great Pyramid
and Stonehenge,* Bonnie Gaunt, Jackson, MI 1985

H. E. Huntley, *The Divine Proportion,* Dover Publications,
New York, NY 1970

Clarence Larkin, *Dispensational Truth,* Clarence Larkin,
Glendale, PA 1918

Robert Lawler, *Sacred Geometry,* Crossroad, New York, NY 1982

Samson H. Levey, *The Messiah: an Aramaic Interpretation,*
Hebrew Union College, Jerusalem, Israel, 1974

Gutman G. Locks, *The Spice of the Torah–Gematria,*
The Judaica Press, Inc., New York, NY 1985

Yacov Rambsel, *Yeshua,* Frontier Research Publications, Inc., Toronto, Ontario, 1996

Jeffrey Satinover, *Cracking the Bible Code,* William Morrow and Company, New York, NY 1997

Michael S. Schneider, *A Beginners Guide to Constructing the Universe,* Harper Collins Publishing, New York, NY 1994

Joseph A. Seiss, *The Gospel in the Stars,* Kregel Publications, Grand Rapids, MI 1972

William Stirling, *The Canon,* RILKO, London, England, 1897

Del Washburn and Jerry Lucas, *Theomatics,* Stein & Day, New York, NY 1977

Books by Bonnie Gaunt

Jesus Christ:
the Number of His Name
$12.95

Beginnings:
the Sacred Design
$12.95

Stonehenge and the Great Pyramid:
Window on the Universe
$12.95

The Stones Cry Out
$9.95

The Magnificent Numbers
of the Great Pyramid and Stonehenge
$9.95

Stonehenge...a closer look
$9.95

All of the above books explore the exciting science of gematria,
the Number Code of the Bible, showing the relationship of the
names and titles of Jesus with the created universe.

PHILOSOPHY & RELIGION

STONEHENGE AND THE GREAT PYRAMID
Window on the Universe
by Bonnie Gaunt
Mathematician and theologian Bonnie Gaunt's study on the Sacred Geometry of Stonehenge and the Great Pyramid. Through architecture, mathematics, geometry and the ancient science of "measuring," man can know the secrets of the Universe as encoded in these ancient structures. This is a fascinating study of the geometry and mathematics encompassed in these amazing megaliths as well as the prophecy beliefs surrounding the inner chambers of the Great Pyramid, the gematria of the Bible and how this translates into numbers which are also encoded within these structures. Interest is high in ancient Egypt at the moment, with attention focused on how old the Sphinx and Great Pyramid really are. Additionally, the current crop circle phenomenon is centered around Stonehenge.
216 PAGES. 6X8 PAPERBACK. ILLUSTRATED. $12.95. CODE: SAGP

JESUS CHRIST: THE NUMBER OF HIS NAME
The Amazine Number Code Found in the Bible
by Bonnie Gaunt
Gaunt says that the numerological code tells of the new Millennium and of a "Grand Octave of Time" for man. She demonstrates that the Bible's number code reveals amazing realities for today's world, and gives evidence of the year of the "second coming" of Jesus Christ. The book reveals amazing evidence that the code number for Jesus Christ has been planted in the geometry of the Earth, ancient megalithic buildings in Egypt, Britain and elsewhere, and in the Bible itself. Gaunt examines the mathematics of the Great Pyramid, Stonehenge, and the city of Bethlehem, which she says bears the number of Jesus in its latitude and longitude. Discover the hidden meaning to such number codes in the Bible as 666, 888, 864, 3168, and more.
197 PAGES. 6X9 PAPERBACK. ILLUSTRATED. BIBLIOGRAPHY. $12.95. CODE: JCNN

THE COMING OF JESUS
The Real Message of the Bible Codes
by Bonnie Gaunt
Gaunt tells us the Codes of the Bible reveal a story that takes us on a magnificent journey through time, and into the amazing realities of today's world. It is exciting to find, encoded into the end-time prophecies, never before published evidence of a timeline for their fulfillment. Gaunt says that clues of this Golden Age to come can be found in the Great Pyramid, Stonehenge, the Bible, and other "ancient texts." Chapters in the book discuss: The Symbol Code and the symbol of the lamb; The Number Code and the ancient system of Gematria; The ELS Code (the amazing Equidistant Letter Sequence code) and the revealing of its message regarding the coming of Jesus; The Constellation Code and how the constellations combine with the number code and the ELS code; and more.
220 PAGES. 6X9 PAPERBACK. ILLUSTRATED. $14.95. CODE: COJ

BEGINNINGS
The Sacred Design
by Bonnie Gaunt
Bonnie Gaunt continues the line of research begun by John Michell into the geometric design of Stonehenge, the Great Pyramid and the Golden Proportions. Chapters in this book cover the following topics: the amazing number 144 and the numbers in the design of the New Jerusalem; the Great Pyramid, Stonehenge and Solomon's Temple display a common design that reveals the work of a Master Designer; the amazing location of Bethlehem; how the process of photosynthesis reveals the sacred design while transforming light into organic substance; how the Bible's number code (gematria) reveals a sacred design; more.
211 PAGES. 6X8 PAPERBACK. ILLUSTRATED. $14.95. CODE: BSD

THE MAGNIFICENT NUMBERS
of the Great Pyramid & Stonehenge
by Bonnie Gaunt
The Great Pyramid and Stonehenge are correlated in an amazing geometry of the Earth, Sun and Moon, giving us insight into the builders of these wonderful monuments. The story told is one of knowledge of time, space and the universe and fills us with profound respect for its architect.
216 PAGES. 6X8 PAPERBACK. ILLUSTRATED. $9.95. CODE: TMN

STONEHENGE ...A CLOSER LOOK
by Bonnie Gaunt
Like the Great Pyramid, Stonehenge is steeped in mystery and is a masterwork in stone. Gaunt decodes the megaliths and tells not only of 4,000 years of history, but of the timeless forces of the universe and of the future of this planet.
236 PAGES. 6X8 PAPERBACK. ILLUSTRATED. $9.95. CODE: SCL

THE STONES CRY OUT
God's Best Kept Secrets Hidden in Stone
by Bonnie Gaunt

Stones are the most permanent, time-enduring objects used by man to record his existence on the planet. Ancient structures such as the Great Pyramid and Stonehenge have endured through more than 4,000 years, hiding their secrets of ancient wisdom. Those stones now cry out to be heard. Their message reveals an insight into the awesome and majestic laws of the universe, and an intimate knowledge of the Creator.
144 PAGES. 6X8 PAPERBACK. ILLUSTRATED. $9.95. CODE: SCO

One Adventure Place
P.O. Box 74
Kempton, Illinois 60946
United States of America
Tel.: 815-253-6390 • Fax: 815-253-6300
Email: auphq@frontiernet.net
http://www.azstarnet.com/~aup

ORDERING INSTRUCTIONS

✓ Remit by USD$ Check, Money Order or Credit Card
✓ Visa, Master Card, Discover & AmEx Accepted
✓ Prices May Change Without Notice
✓ 10% Discount For 3 or more items

SHIPPING CHARGES

United States

✓ Postal Book Rate { $2.50 First Item
 50¢ Each Additional Item
✓ Priority Mail { $3.50 First Item
 $2.00 Each Additional Item
✓ UPS { $3.50 First Item
 $1.00 Each Additional Item

NOTE: UPS Delivery Available to Mainland USA Only

Canada

✓ Postal Book Rate { $3.00 First Item
 $1.00 Each Additional Item
✓ Postal Air Mail { $5.00 First Item
 $2.00 Each Additional Item
✓ Personal Checks or Bank Drafts MUST BE
 USD$ and Drawn on a US Bank
✓ Canadian Postal Money Orders OK
✓ Payment MUST BE USD$

All Other Countries

✓ Surface Delivery { $6.00 First Item
 $2.00 Each Additional Item
✓ Postal Air Mail { $12.00 First Item
 $8.00 Each Additional Item
✓ Payment MUST BE USD$
✓ Checks and Money Orders MUST BE USD$
 and Drawn on a US Bank or branch.
✓ Add $5.00 for Air Mail Subscription to
 Future Adventures Unlimited Catalogs

SPECIAL NOTES

✓ RETAILERS: Standard Discounts Available
✓ BACKORDERS: We Backorder all Out-of-
 Stock Items Unless Otherwise Requested
✓ PRO FORMA INVOICES: Available on Request
✓ VIDEOS: NTSC Mode Only
✓ For PAL mode videos contact our other offices:

European Office:
Adventures Unlimited, PO Box 372,
Dronten, 8250 AJ, The Netherlands
South Pacific Office
Adventures Unlimited NZ
221 Symonds Sreet Box 8199
Auckland, New Zealnd

Please check: ☑

☐ This is my first order ☐ I have ordered before ☐ This is a new address

Name					
Address					
City					
State/Province			Postal Code		
Country					
Phone day		Evening			
Fax					

Item Code	Item Description	Price	Qty	Total

Please check: ☑

☐ Postal-Surface
☐ Postal-Air Mail
 (Priority in USA)
☐ UPS
 (Mainland USA only)

Subtotal →	
Less Discount-10% for 3 or more items →	
Balance →	
Illinois Residents 6.25% Sales Tax →	
Previous Credit →	
Shipping →	
Total (check/MO in USD$ only)→	

☐ Visa/MasterCard/Discover/Amex

Card Number

Expiration Date

10% Discount When You Order 3 or More Items!

Comments & Suggestions	Share Our Catalog with a Friend

24 HOUR CREDIT CARD ORDERS—CALL: 815-253-6390 FAX: 815-253-6300
EMAIL: AUPHQ@FRONTIERNET.NET HTTP://WWW.AZSTARNET.COM/~AUP